CHURCHES OF STAFFORDSHIRE

HELEN HARWOOD

AMBERLEY

Thanks to Mel and the many clergy and parishioners for their assistance

This edition first published 2024

Amberley Publishing
The Hill, Stroud
Gloucestershire GL5 4EP

www.amberley-books.com

Copyright © Helen Harwood, 2024

The right of Helen Harwood to be identified as the Author
of this work has been asserted in accordance with the
Copyrights, Designs and Patents Act 1988.

British Library Cataloguing in Publication Data.
A catalogue record for this book is available from the British Library.

ISBN 978 1 3981 1265 0 (print)
ISBN 978 1 3981 1266 7 (ebook)

Typesetting by SJmagic DESIGN SERVICES, India.
Printed in Great Britain.

CONTENTS

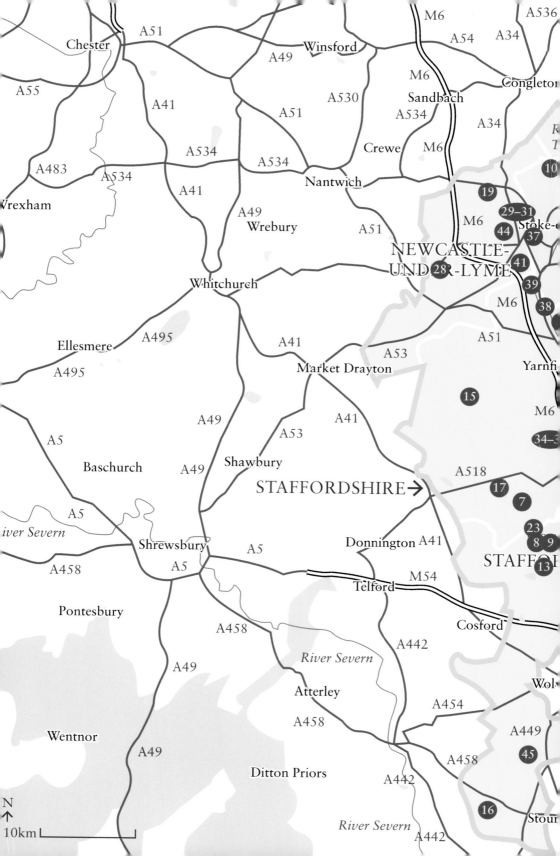

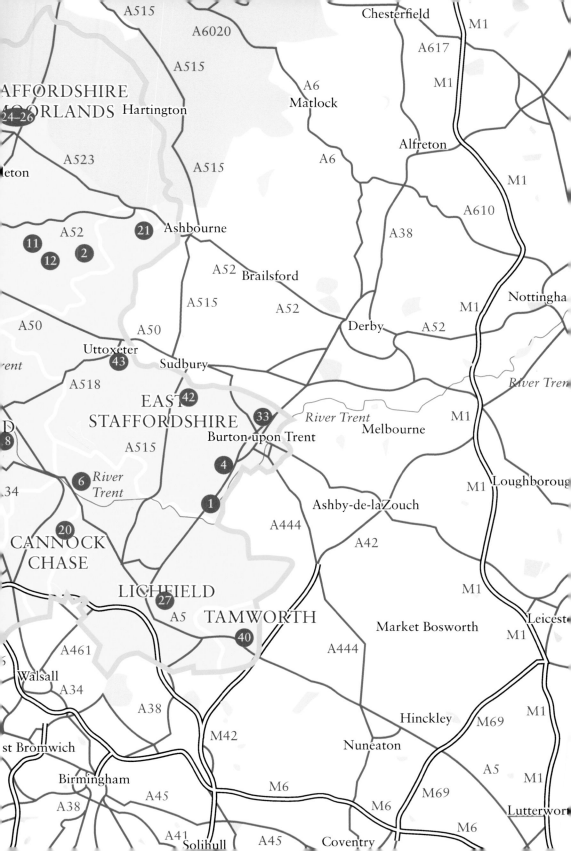

INTRODUCTION

This area of Britain which is now Staffordshire was known to the Druids as the 'Holy District'. The name appears to have originated in the fact that the principal Druidical temple stood close to modern-day Cannock – then a great forest. Later, after the Romans invaded Britain in AD 43, the Druids were outlawed and Britains worshipped native pagan deities. When the Roman Emperor Constantine the Great (AD 306–37) became the first Roman emperor to convert to Christianity, legalising it in 313, it became the ascendant religion of the Roman Empire. In 325 he called the first council of Nicaea from which Christians profess the Nicene Creed. Christianity was made the religion of the Roman Empire by Theodosius I in 391 and by the fifth century it was well established with the building of many churches, which in Britain were mainly of wooden construction. But when the Empire fell in Britain in 383–410 it was followed by the sixth-century Saxon invasion, the destruction of churches and the subsequent return to Paganism.

Staffordshire, due to its vast forests, was very isolated when Christianity returned to the Anglo-Saxons with the Celtic Church in Ireland, Wales, Cornwall and from the Monastery of Lindisfarne, Northumbria. Indeed, St Chad was from Northumbria and was British Celtic. To the south St Augustine arrived in Kent from Rome in 596 where he converted Aethelbert, the King of Kent. Canterbury was the Kentish kingdom's capital and so it became the seat of the pre-eminent Archbishop of England.

The church alone bound the often-warring Anglo-Saxon kingdoms together, spreading the gospels from established monasteries via monks travelling from village to village. It was nearly eighty years from the time of St Augustine to the preaching of St Chad at Lichfield in 675.

When Christianity re-arrived in the Midlands, Staffordshire was at the centre of the Kingdom of Mercia and for over 400 years of the Mercian period the faith was an inspiration to missionaries, hermits and healers. The Staffordshire Hoard, which includes crucifixes, is considered to have been buried around AD 700.

While St Chad was not the first Bishop of Lichfield – that was St Diuma (656–8) – he is credited with bringing Christianity to Mercia. It was King Wulfhere who granted a parcel of land to Chad at Lichfield with the intention that he build a monastery there and this became the centre of the diocese of Mercia. In 669 Wulfhere appointed Chad Bishop of Lichfield to minister over a Mercian see which stretched from the River Humber to the Mersey and from the River Severn to the Thames. St Chad died on 2 March 672 and was buried at Lichfield.

By this time churches were mostly constructed of stone, small and rectangular in shape, whilst houses continued to be built of wood with thatched roofs. Then in the time following the Norman Conquest of 1066, when the Romanesque style of

architecture arrived in Britain with bigger churches cruciform in shape, a central tower and large windows until the Church Building Act of 1818 and the Catholic Emancipation Act of 13 April 1829, only a minority of new churches were built.

The Parliamentary Church Building Act provided a fund of £1 million for the building of new churches to commemorate the ending of the Napoleonic Wars and to serve a growing urban population. Known as 'Waterloo churches', 'Commissioners churches' or 'Million Act churches', each would have a budget of £20,000 and conform to the 'High Church' beliefs of the time with an emphasis on Gothic architecture, a style that cost less than neoclassical. Of the 612 churches built across the country for the commissioners, 550 were Gothic. A further £500,000 was granted in 1824. These included: St George, Newcastle, 1827–8; Christ Church, Tunstall, 1830–1; St Mark, Shelton, 1831–3; St James the Less, Longton, 1833–4; St Thomas, Mow Cop, 1841–2; Holy Trinity, Chesterton, 1851–2; Holy Trinity, Sneyd, 1851–2; St Luke, Hanley, 1852–4; and St Luke, Silverdale, 1853.

To give him his full name, it was Augustus Welby Northmore Pugin who laid down the principles of the Victorian Gothic revival and by the mid-1850s it had become the accepted architectural style in Britain.

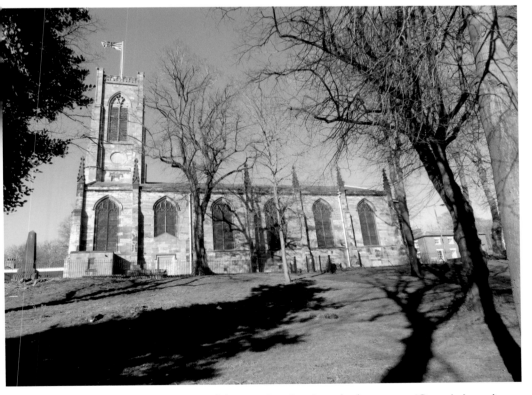

St George's Church, Newcastle, one of the Waterloo churches, also known as a 'Commissioners' or 'Million Act' church. (Author's collection)

1. ALREWAS, ALL SAINTS ANGLICAN CHURCH

A Saxon church stood in Alrewas where two ancient tracks crossed; one was the Salters way and the other led from Lichfield to the north-east and where traditionally it is said that Lady Godiva worshipped. In AD 822 the settlement became a prebend of Lichfield under Aethelward with the responsibility of financing a priest at Lichfield Cathedral who would have had overall care of the village church through an appointed priest. Gradually, pastoral oversite became the priest's responsibility and today the vicars of Alrewas continue to receive their 'cure of souls' directly from the Bishop of Lichfield.

Over time Grade I listed All Saints has undergone several major changes beginning in the late twelfth century when it became a rectangular stone Norman church probably occupying the present nave. The tower and north aisle doorways together with some roughly hewn stones in the north wall are all that remain today. Later, in the thirteenth century the chancel was built with lancet windows, piscine, sedilia, priest's door and an unusual small window in the north wall. Thought initially to be a leper window, it was more likely to be for villagers who, when hearing the Sacring bell, could see the elevated Host at Mass. A fifteenth-century octagonal font has four grotesque lion heads at the base. During the Reformation clerestory windows were added above the new south aisle and a

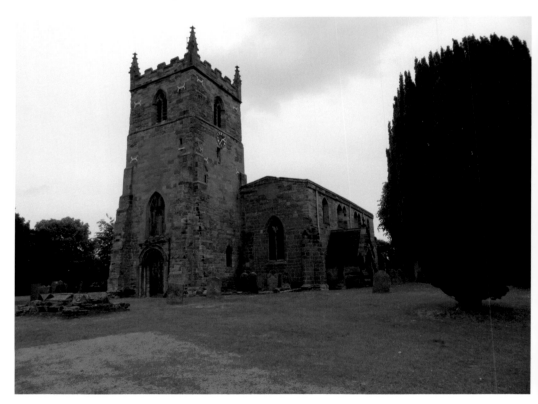

All Saints Parish Church, Alrewas. (Author's collection)

nave roof carved with clustered leaves. During the reign of King Charles I an oak altar table was introduced in 1638, a pulpit in 1639 – considered to be one of the best examples of seventeenth-century woodwork – and silver paten dated 1642.

A chancel restoration of 1877 saw the early east window glazed with stained glass and the exciting discovery of some rare medieval paintings hidden away for centuries under the limewashed walls. In 1891 the then vicar, W. A. Webb, financed the north aisle extension to make the church symmetrical and a new rood screen, which included parts from an older one, erected in its original place. As early as 1585 the church was recorded as having two bells while the present ring of eight were recast in 1922 with a twelve hundredweight tenor and the addition of a new treble and second bell.

The parish was home to some memorable clerics. Two former curates of All Saints went on to have illustrious careers. The Revd Alfred Ainger, a curate in the mid-nineteenth century, became a celebrated biographer and hymn writer composing 'God is working His purpose out', and Revd John Selwyn, son of the first Bishop of New Zealand George Augustus Selwyn, was curate at Alrewas in 1869–70 and later became Bishop of Melanesia in the south-western Pacific Ocean and then Master of Selwyn College, Cambridge (named after his father).

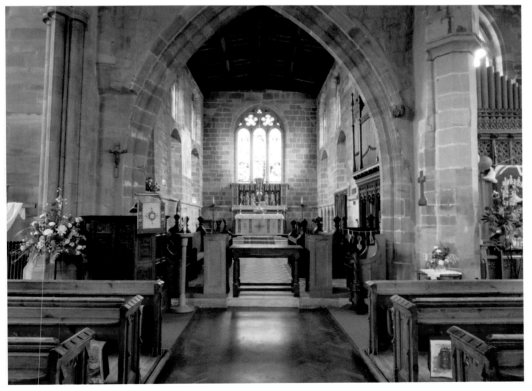

The altar table and pulpit, considered one of the best examples of seventeenth-century woodwork. (Author's collection)

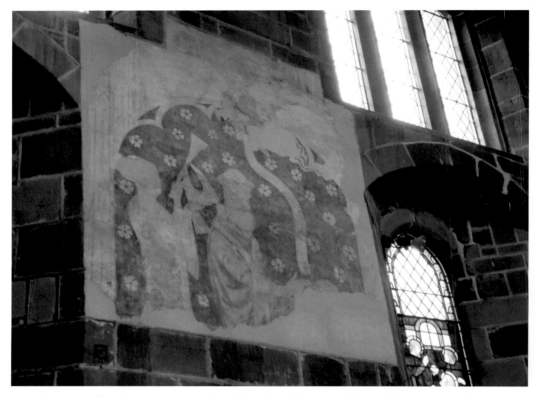

The rare medieval painting on the chancel north wall discovered during the restoration of 1877. (Authors collection)

In the porch lies the grave of Mathias Langley, vicar from 1708 to 1728 who requested that after his death he was to be buried in front of the south door as 'parishioners had walked over him during his lifetime so they should after his death'.

2. ALTON, ST JOHN THE BAPTIST ROMAN CATHOLIC CHURCH

In the 1830s when John, 16th Earl of Shrewsbury and his architect Augustus Pugin had completed Alton Towers, they turned their attention to the needs of the poor people in Alton village on the far side of the Churnet Gorge.

Within the precincts of the old castle Pugin designed the hospital – in a medieval style – of St John the Baptist with almshouses, chapel, guildhall and a school for poor children. Built in Tudor Gothic style, it occupied three sides of a square. Paid for by the Earl, it was named after his patron saint. Pugin said of the site, it is 'one of the most beautiful and suitable for such an edifice which can well be imagined'.

Work began using local sandstone on the north side of the quadrangle in 1840 which included St John's Chapel-school and the warden's house. The altar was consecrated on 13 July 1842 by Bishop Walsh.

Joined at a north-western angle to the hospital, the church was built to a simple design of nave, chancel, a Blessed Sacrament chapel on the north side of

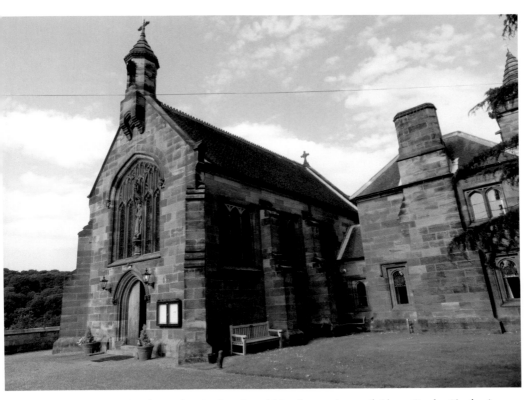

The Catholic church of St John the Baptist within the precincts of Alton Castle. (Author's collection)

the chancel and a bellcote. This became the model for many of Pugin's country churches and was often copied by other architects.

Originally, the nave served as a schoolroom separated from the chancel by a stone arch with large wooden doors which could be opened for services; their hinges can still be seen. At Pugin's insistence the floor was wooden – as opposed to the Minton tiles used in the rest of the chapel – to be warmer for bare-footed children. The lessons were taught from the pulpit to pupils seated on benches used as pews for Mass and which were turned into desks by raising a wooden flap. Some of the hand-carved oak benches are at the front of the church. Each is different with one depicting Bishop Walsh and another John Talbot. Pugin also offered practical facilities for the children. 'I have arranged the privies for the school in a most picturesque manner. You descend to them by steps cut [out of] the side of the rock and they are hid amongst the trees.'

During the First World War the buildings, apart from the castle, were sold by the Towers Estate and in 1930 when the debt was paid, St John's was consecrated as a parish church.

Prior to 1967 the church had a wooden rood screen of which only the crucifix suspended from the roof remains; the rest of the screen is now in Birmingham

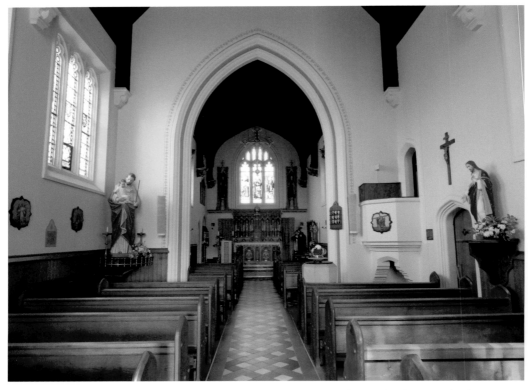

Inside the church, a model for many of Pugin's country churches and a former schoolroom where lessons were taught from the pulpit. (Author's collection)

Museum. To the left of the altar is the tomb of John Talbot, 16th Earl Shrewsbury who died in 1852, and to the right is his widow, Mary Theresa, who died in 1856.

Outside, the statue above the entrance is that of St Nicholas, the patron saint of children – as opposed to the church's patron, St John the Baptist. In the grounds stands a wooden Calvary below a tiled gable. Apparently, it is only the second one to be erected following the Reformation; the first was at Grace Dieu, Leicestershire.

3. ASTON BY STONE, HOLY MICHAEL ARCHANGEL ROMAN CATHOLIC CHURCH

The present church of Holy Michael Archangel was built in 1882 on a site of great historical importance long associated with Catholic recusants and the Passionist priest Blessed Dominic Barberi. Aston Hall stands on an ancient site defined by a large dry moat and owned in the sixteenth century by the recusant Heveningham family. Passing through several families, it was rebuilt *c*. 1798 and in 1814 Cardinal Weld gave the hall to the English Franciscans as a noviciate. From 1829 to 1837 it served the Bridgettine nuns.

Holy Michael the Archangel Catholic church, Aston by Stone, considered to have been built by James Trubshaw. (Author's collection)

Soon after arriving at Aston Hall in 1838, Revd Benjamin Hulme discovered the bones of St Chad under the hall chapel altar still in the box of 1665. Taken from Lichfield at the Reformation, they eventually passed into the hands of the Fitzherberts of Swynnerton and were later taken to Aston Hall in 1797. Following a spell at Oscott college in Birmingham, the bones (which have more recently been authenticated by carbon dating) were translated to St Chad's Catholic Cathedral, Birmingham, in 1841 where they lie in a casket designed by A. W. N. Pugin above the High Altar.

St Michael's Church was built in 1847–9 by Blessed Dominic Barberi from plans by C. F. Hanson, the favourite architect of William Ullathorne, the first Bishop of Birmingham. 'Anything that Pugin can do Mr Hanson can do better,' the bishop declared. Unfortunately, Barberi never saw the finished chapel as he died suddenly before it opened in 1849. In 1856 a Lady Chapel extension was added, and the hall rebuilt to designs by E. W. Pugin. It was Blessed Dominic who received St John Henry Newman into the Catholic church.

The chapel building was later to be considered unsafe. The short chapel and truncated stone tower to the rear of the hall are remains of the Hanson and Pugin church; the rest was demolished in 1880.

The present, smaller sandstone church lies to the north-west of the moat where the foundation stone was laid in January 1882 and was constructed with materials

The chapel in nearby Aston Hall where Revd Benjamin Hulme discovered the bones of St Chad hidden underneath the altar. (Author's collection)

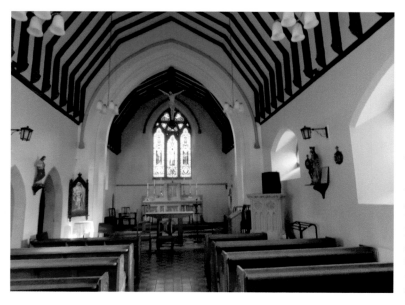

The interior of St Michael's with furnishings commissioned by Blessed Dominic Barberi and designed by C. F. Hanson. (Author's collection)

incorporated from the former chapel. A small tower was added in 1899. There is some uncertainty as to the architect, which was considered to be James Trubshaw. However, the church bears similarities to others designed by Hanson and so the involvement of his nephew J. S. Hanson cannot be ignored. Some of the stained glass predates the church and the furnishings. The carved altar, pulpit and font are those commissioned by Blessed Dominic Barberi and designed by C. F. Hanson.

Today Aston Hall is the diocesan home for retired priests.

4. BARTON UNDER NEEDWOOD, ST JAMES ANGLICAN CHURCH

The parish church of St James, with a 14cwt ring of eight bells, had an unusual beginning in Tudor times. It was earlier, *c.* 1480, that William Taylor – a game warden – and his wife Joan were blessed with triplets: John, Rowland and Nathaniel. For all the boys to survive was such a rarity that when King Henry VII came hunting in Needwood Forest the children were presented to him, and the king, who saw them as a sign of the Trinity, offered them his protection.

All three became doctors, but it was John whose career as a cleric led him to be appointed as a Tudor civil servant and in 1509 Prebendary of Eccleshall at Lichfield Cathedral. Later, under King Henry VIII he was made King's Clerk and Chaplain, being spokesman at meetings with foreign envoys and even writing speeches for the King. In June 1520 John accompanied Henry VIII to his meeting with King Francis I of France at the Field of the Cloth of Gold. An accomplished lawyer in both civil and ecclesiastical law, he was made Master of the Rolls in 1527 and became one of the commissioners questioning the validity of King Henry VIII's marriage to Catherine of Aragon.

John Taylor served the King for twenty-five years, but he did not forget the humble cottage where he was born. On or close to its site he built a new church as his blessing and gift to the village. Begun in 1517 and completed in 1533, it replaced the medieval church of St Mary Magdalene – though in the sensitive times of the Reformation she was considered to be a Catholic saint, so St James, whose feast day of 25 July falls three days after that of St Mary Magdalene, was thought a more appropriate dedication. The church is a rare example of one began and completed in a single lifetime. John Taylor died in 1534.

Today the church nave and chancel still have their low-pitched roofs with an unusual three-sided apse in the chancel and windows with some of the original glass. An arch in the chancel wall was possibly designed to accommodate Taylor's tomb – though he is thought to be buried in London. Taylor's coat of arms – three heads, violets and the Tudor Rose – can be found in several places both inside and on the outside of the church.

St James', like a lot of churches, was subjected to Victorian reordering. In 1860 the aisles were widened and the dark wooden galleries which ran along the sides of the building removed, so enabling the smaller, rectangular windows to be replaced with larger Gothic-style ones. Then four years later the large seventeenth-century three-decker pulpit which stood in the centre of the nave to the north side – in which the vicar would have preached from the top section while the clerk led prayers from the deck below – was taken out and a new one installed at the front. Also the box pews – some of which were marked

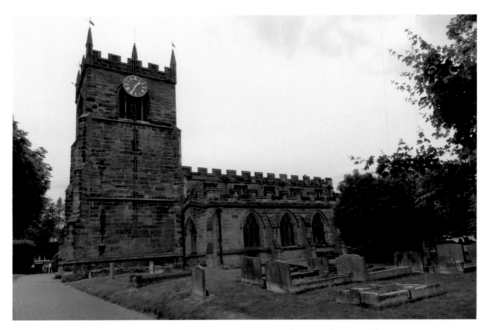

St James, Barton-under-Needwood, built by Dr John Taylor. (Author's collection)

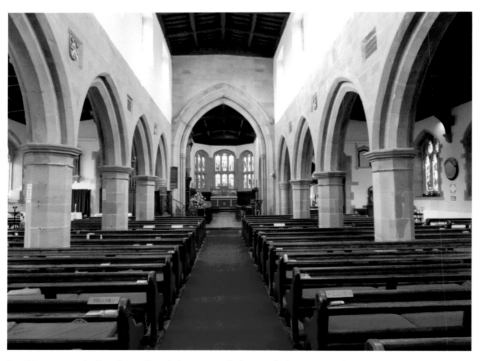

Looking towards the chancel and the unusual three-sided apse. (Author's collection)

'free' making them available to the ordinary villagers – were replaced and a new chancel arch built. In 1885 the chancel and nave floors were tiled with Minton tiles and the original Tudor panelling exchanged for oak. The altar and reredos (presumably to replace a communion table) was added along with the choir stalls and organ. The communion rail, though, is much older and dates from medieval times.

St James' became a parish church in 1818 prior to which it was a Chapel of Ease of Tatenhill. Much later, a Chapel of Peace was dedicated at Easter 1946 to remember those killed in battle. It was one of the first such chapels in the country.

5. BIDDULPH, ST LAWRENCE ANGLICAN CHURCH

Standing on the site of the present church was a small oak-built chantry chapel which was said to have been destroyed by the Danes *c.* 850–AD 900 and later replaced with a stone Saxon church which possibly fell into disrepair. Following the Norman Conquest, the majority of Staffordshire was under William's jurisdiction and was mostly wasteland – possibly a deliberate act as there had been local resistance to the Normans. The Domesday survey records: 'All this land of the King is waste.'

Over 900 years ago Orm (Ormus) Le Guiden, Lord of Knypersley and ancestor of the Biddulph family, returned from the Crusades with seven stonemasons which legend claims were Saracens while others say Egyptians or Phoenicians. However, the latter seems to be less likely as the Phoenicians were a seafaring people and although they traded with Britain, there was no reason for them to settle inland. Later accounts tell of a long-established group of their descendants living on Biddulph Moor. Meanwhile, the old church of St Lawrence founded by Orm in the eleventh century was considered to have had some Eastern influence in its architecture, probably due to the Saracen stonemasons, though only the bottom part of the tower has survived. By the late twelfth century it was a parish church for the settlements of Over, Middle, Nether Biddulph and Knypersley.

In 1391 following the death of Nicholas, Lord Audley, a royal licence was granted to the Cistercian Hulton Abbey for 1 acre of land at Biddulph along with the church there to help with the Abbey's financial problems following the Black Death 1346–53. The monastery received a yearly income of *6s 8d* (34p) from the parish and the right to appoint secular clergy, of which there were many, as the living was a poor one – between 1400 and 1415 there were five priests. One, John Ray, left in 1415 to become Rector of Upper Langwith in Derbyshire, while another, Andrew Valentyne, was accused of stealing twelve oxen in 1432. At the Dissolution of the Monasteries in 1535 Biddulph parish was valued at £4. 10s (£4.50). Then St Lawrence's would have been newly rebuilt just twelve months earlier, probably by lay benefactors.

Later, during the Civil War Cromwell's soldiers attacked the church, breaking the stained-glass windows, the fragments of which were collected and saved by the vicar. Today they can still be seen in the east window.

James Bateman bought the Biddulph and Knypersley estates in 1824 when his only son, John, began work to rebuild the damaged church, which reopened in

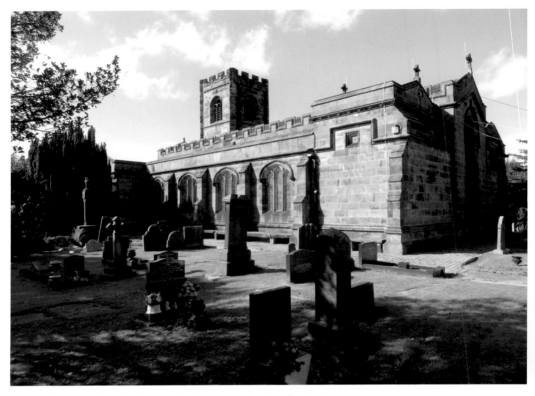

St Lawrence Parish Church, Biddulph. (Author's collection)

Some of the Grade II engraved coffin lids alongside the church wall associated with the Knights Templar. (Author's collection)

1836. A fire partially destroyed the tower in 1872. A new organ and a 10cwt ring of six bells were presented by Robert Heath in 1873.

Outside stands a preaching cross from the time of the Black Death and around the side of the church are eight Grade II listed coffin lids engraved with crosses, swords and battle-axes. The swords and crosses are a representation of the Knights Templar who were on the Third Crusade in 1189–92, suggesting St Lawrence's may have been associated with the Order. They could, though, be the tombs of local men who, having gone on Crusade, survived to return home and be buried there. Others are of the opinion they are Norman and the weapons symbolise their trade.

6. BLITHFIELD, ST LEONARD'S ANGLICAN CHURCH

The Grade I listed St Leonard's Church was built as a mortuary chapel for the Bagot family of Blithfield Hall. In 1360 Ralph Bagot walked 2 miles to the home of Richard de Blithfield's heiress and married her, so establishing the family. It is one of country's oldest who over generations have been at Crecy (1346), Poitiers (1356), Agincourt (1415), Bosworth (1485) and Naseby (1645). Indeed, Lewis Bagot was knighted at the marriage of Prince Arthur to Catherine of Aragon, 14 November 1501, and he left instructions that following his death, 31 May 1534, a priest be paid 40 shillings (£2) a year plus meat and drink 'to sing for me' in Blithfield church for two years.

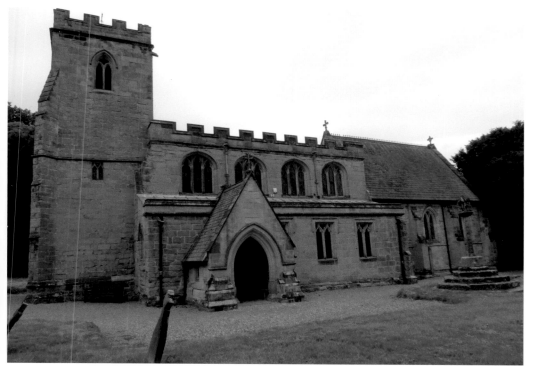

The Grade I listed church of St Leonard, Blithfield, built as a mortuary chapel for the Bagot family. (Author's collection)

The church dates from the thirteenth century and in the early fourteenth century four-bay 'arcades' along with the base of the tower were added. The upper tower and stained glass in the west window is considered to date from 1525. By 1851 the chancel was in need of some restoration and Augustus Pugin, who was probably introduced to the Bagots by Lord Shrewsbury, undertook the commission. It was said that he reproduced the original building; however, comparison with a painting done just before work started discredits the theory. Although Pugin retained the Bagot memorials, sedilia and piscina, he added a pitched roof – as opposed to the perpendicular flat one – and a five-light east window with intersecting tracery replaced the three-light one, the glass of which was unfortunately replaced in 1965. The panes in the south clerestory window depicting saints Peter, James and John by Pugin have survived.

Inside there is an unusual step down from the nave to the chancel. The pews are four-hundred years old. An oak altar table inlaid with roses and foliage is possibly unique as it said to have once been part of a farm bedstead! An offertory box has been adapted from a rare twelfth-century pillar piscina.

The tower has an 8cwt ring of six bells, two of which were the gift of Hugh Lupus, Duke of Westminster, to Lord Bagot on his coming-of-age, 19 January 1878; another was added in 1887. Much earlier, bells had rung for the marriage

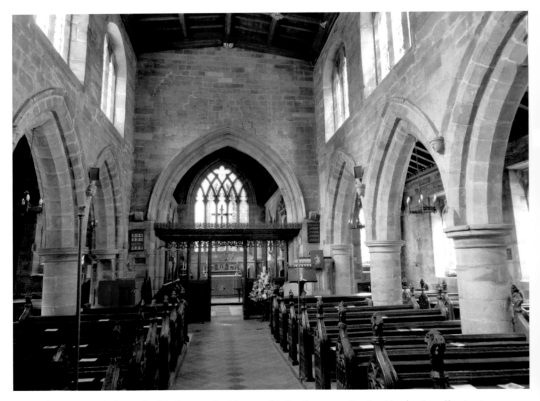

The nave and chancel of St Leonard's. The roof is by Augustus Pugin. (Author's collection)

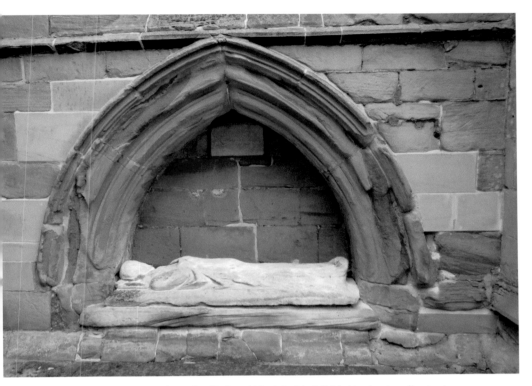

The twelfth-century recessed tomb of Priest Alfred de Blythfield. (Author's collection)

of William Bagot to Emily Fitzroy – descended from King Charles II through his natural son Duke of Grafton – in May 1799 and then tolled for her funeral in June 1800 following childbirth. On New Year's Day 1801 they tolled again for the death of their baby daughter.

Outside and recessed into the south wall of the chancel is the twelfth-century recumbent figure of Alfred de Blythfield, priest of Hulcombe who preached at St Leonard's some 700 years ago before the church tower was erected. The style of tomb with an arch, once highly decorated, is peculiar to Staffordshire. Close by in the churchyard stands an ancient cross which is probably older than the church carved with birds, a ship and a crowned lion. It was restored in 1904.

7. Bradley, St Mary's Anglican Church

Originally dedicated to St Mary and All Saints, the church's Lady Chapel was dedicated in 1343. In the chancel is a thirteenth-century priest's doorway complete with medieval wooden door. Interestingly, the north arcade is dated as mid-fourteenth century; however, there is some speculation that it originated in the Augustinian priory in Stafford – dissolved August 1538 – and was reconstructed at Bradley in 1542 as records tell of cartloads of stone being purchased by the churchwardens. The church has a later print of the north side *c.* 1798 depicting it before the north aisle windows were restored.

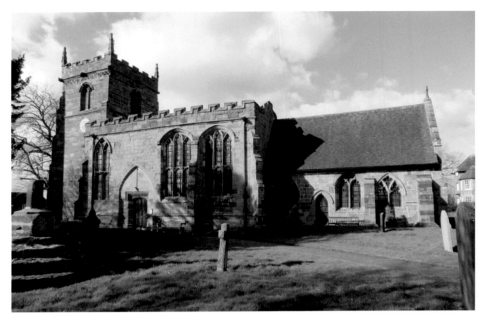

St Mary's Church, Bradley. (Author's collection)

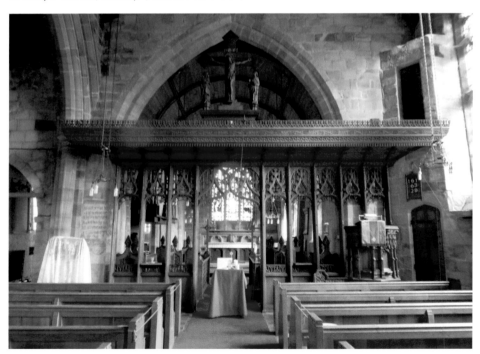

The interior of St Mary's with the rood loft above the chancel screen and the north arcade to the left. (Author's collection)

Inside are the remains of a very rare fourteenth-century reredos incorporated into the east wall, a panel of medieval floor tiles and a decorated twelfth-century Norman font of Saxon design.

Grade I listed St Mary's was restored in 1906–8 by William Douglas Caroe (1857–1938), an important figure in the Arts and Crafts movement who specialised in restoring historic churches. Then, the present chancel roof was constructed leaving the medieval one in place above it. Caroe also designed the chancel screen with a rare rood loft above adjoined to the original medieval stairway on the south side. It was dedicated in 1914.

8. BREWOOD, ST MARY THE VIRGIN AND ST CHAD ANGLICAN CHURCH

St Mary's shares its dedication with Lichfield Cathedral, possibly because the bishops were Lords of the Manor of Brewood – with a manor house in the parish – and hunted in nearby Bishop's Wood. The unusually large church was used as a sub-cathedral and dates from around the thirteenth century. The Early English chancel is some 700 years old and probably replaced a smaller, earlier one. Later, in the fourteenth century the north aisle was added with the rest of the church rebuilt in the fifteenth century.

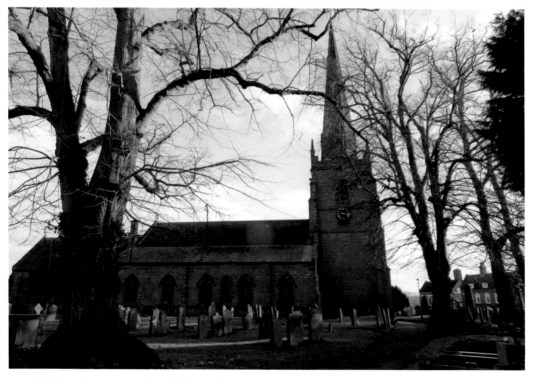

St Mary the Virgin and St Chad's Anglican Church, Brewood. (Author's collection)

In the chancel are several tombs of the Roman Catholic Giffard family who were major contributors to the church. Sir John Giffard, who famously shot a leopard, lies there and another Sir John died in 1613 following a long imprisonment as a loyal Roman Catholic. It was his son Gilbert Giffard who was implicated in the Babington Plot of 1586 to free Mary, Queen of Scots, though working as a double agent for both Catholics and Protestants he disgraced his family. Another memorial is a brass tablet to Jane Leveson, 1572, the wife of Edward Leveson. For many years it was lost from the church only to be discovered built into the stationmaster's house at the local Four Ashes railway station which operated from 1837 to 1959. Possibly it was mislaid during the church's restoration of 1878–80 at a cost of £6,600 by George Edmund Street (1824–81), one of the finest High Victorian Gothic architects of the nineteenth century.

St Mary's Church tower has a 21cwt ring of eight bells, and these bells were the first ever to be electronically tuned, in 1896, using the scientific or 'Simpson' method.

Outside, according to church records is the unmarked grave of Colonel William Carlos who hid in the famous oak tree with King Charles II at nearby Boscobel in 1651.

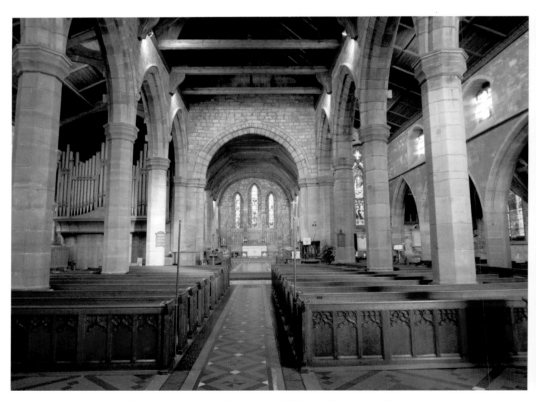

St Mary's, restored by George Edmund Street in 1878–80. (Author's collection)

9. BREWOOD, ST MARY'S ROMAN CATHOLIC CHURCH

St Mary's Roman Catholic Church was designed by Augustus Pugin in 1843–4 and cost £1,345 to build. Much earlier, recusant Thomas Giffard had purchased the former Benedictine Black Ladies priory in 1539 where the timber-framed chapel, built *c*. 1790, was used for public services. Catholicism had long been tolerated in the area, granted by a personal promise from King Charles II for his rescue following the Battle of Worcester in 1651. The Chillington estate, Longbridge too, the home of the Midland District Vicars Apostolic until 1804, also had a chapel with its own-priest-in-charge from at least 1779. However, by around 1840 the chapels were too small to accommodate the growing Catholic population, which was mostly employees and their families from the estate.

St Mary's Church was founded by Fr Robert Richmond and built by George Myers on land paid for by Thomas Giffard and which had originally belonged to Black Ladies priory, at a cost of £486. Designed by Augustus Pugin in the Early English style, the church was consecrated on 13 June 1844 by Bishop Wiseman. Pugin also designed the nearby presbytery and old school at a total cost of £2,010. Built of red sandstone, Augustus wrote to Lord Shrewsbury: 'The church can stand due east and west with a south porch to the road, and a church in such a situation for an old Catholic population is most interesting.' The Giffards paid the living expenses of the early parish priests.

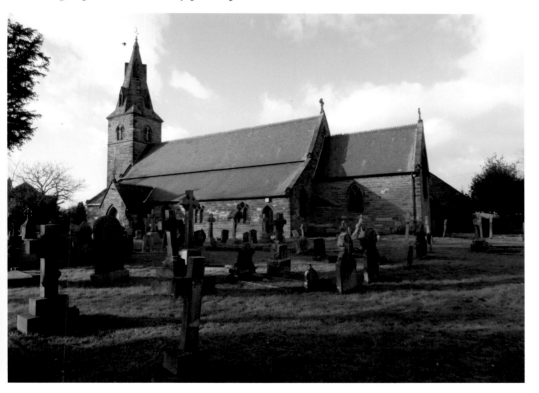

St Mary's Catholic Church, Brewood. (Author's collection)

The church has a west broach tower, home to a single bell; a nave with no clerestory; and north and south aisles. Unusually for a nineteenth-century church there is a hagioscope giving a view of the High Altar, suggesting it may have been designed as a family chapel. In 1887 the church was redecorated and a stone altar placed in the Lady Chapel. Then, following the Second Vatican Council (11 October 1962–8 December 1965), the rood screen and communion rails were removed, a new 'cube' altar brought forward, and the font was moved to the east end of the south aisle. Today, the Pugin altar survives, as do three stained-glass windows, Augustine's gift. The painted wood crucifix in the south aisle is original to the church; it formerly sat above the rood screen.

Above the Lady Chapel altar and set in an alabaster twentieth-century shrine sits the partly painted *c.* seventeenth-century wooden statue of the Blessed Virgin Mary and Child, known as 'Our Lady of Brewood'. She is probably the most interesting piece in the church, originally from the convent chapel of Black Ladies when it was ransacked and set alight by Parliamentary troops searching for Charles II. During the attack the statue was cut by a sword above the right knee and a musket ball created a hole in the back. Even now, and despite changes in atmospheric conditions, the wounds continue to seep water. In James Hicks Smith's 1867 account of Black Ladies, he wrote 'A ponderous little statue of the Blessed Virgin, carved in wood, continuing to occupy the place of the altarpiece.'

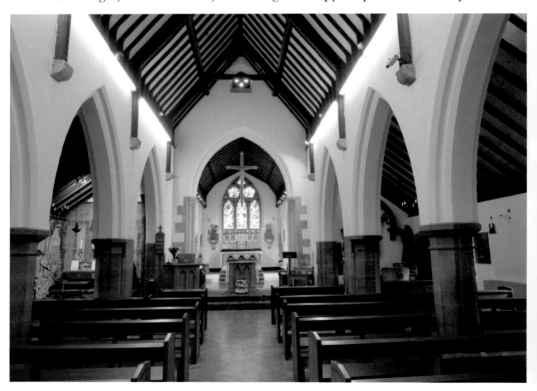

The interior of St Mary's, Brewood. (Author's collection)

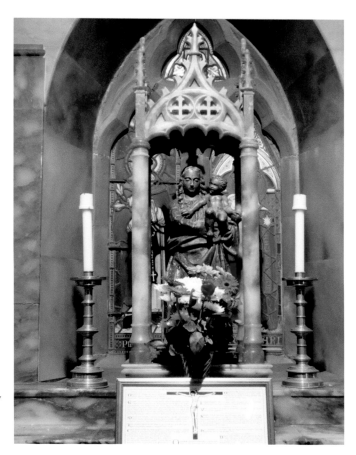

The statue of Our Lady of Brewood damaged by Parliamentary soldiers during the Civil War. (Author's collection)

Outside by the south porch sits a *c.* twelfth-century stone piscina which is reputed to have come from White Ladies nunnery just over the county border in Shropshire.

10. BURSLEM, ST JOSEPH'S ROMAN CATHOLIC CHURCH

Two years after the dissolution of Hulton Abbey, Rushton Grange was sold by James Leveson to Richard Biddulph for £130.7s (£130 35p) on 7 February 1540. Here, in Mr Jacob Warburton's Grange House, was a chapel for family and neighbours. It was the first post-Reformation Catholic centre in the area and it is claimed that the priest attended to Burslem's plague victims in 1647. The Cobridge mission began in 1760 with the first priest, Fr Thomas Flynn, living in Burslem.

The construction of St Joseph's was akin to a parish DIY project on a memorable scale. In 1895 St Peter's, Cobridge, founded an independent mission to Smallthorne, Wolstanton and Burslem where Masses were held at Hill Top Pottery on Westport Road (previously called Liverpool Road). The following year an area of land was purchased in Hall Street and the foundation stone was laid in 1897

of a building which included both church and school. The school, on the ground floor with the church above, opened on St Patrick's Day, 17 March 1898.

In 1908 Fr William Browne arrived in Burslem and subsequently had big plans to build the present church. A great motivator, he got parishioners and local men to demolish a derelict factory and prepare the new church's foundations. In the hard times of the 1920s he offered a free daily meal to the unemployed miners and pottery workers if they would work on the project. It was on 17 September 1925 that the foundation stone was laid, by Vicar General Right Reverend Monsignor Cronin.

St Joseph's was designed by John Sydney Brocklesby in the North Italian Lombardic style. It was built under the guidance of contractors Messrs Booth and Sons of Banbury with red and purple bricks in a herring-bone pattern manufactured at Fenton Colliery brickworks.

Of the two west towers, one is small and round while the other is square and home to a 40.0.22cwt bell which is included in Dove's list of notable British bells. The inscription reads: 'JOSEPH SANGTE SPONSE MAGNE MARIAE VIRGINIS ME RITE TIBI DEDICAT REV. GULIEMUS BROWNE PAROCHUS 1925.' (*'Holy Joseph, great husband of the Virgin Mary, I am duly dedicated to you by the Rev. William Browne, parish priest 1925')*. The estimated cost of the bell and fittings came to £400; however, Taylors – the bell casters – accounts record two receipts for £300 and £99 11s 1/2d (£99. 56p). No one appeared to notice the shortfall of 8s/10d (44p).

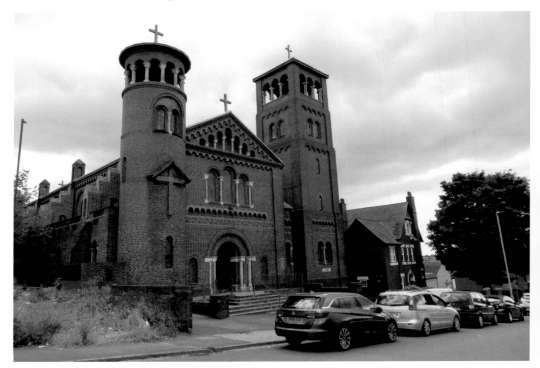

St Joseph's Catholic Church, Burslem, designed by John Sydney Brocklesby. (Author's collection)

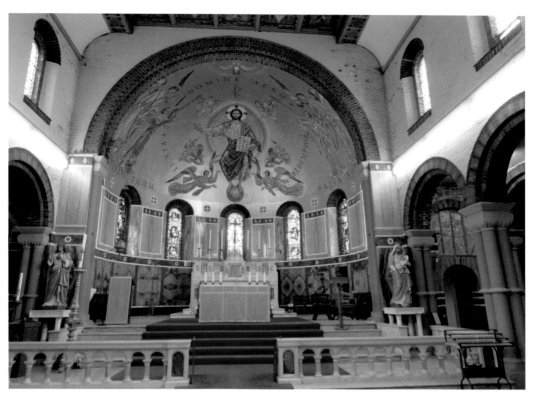

St Joseph's altar with the huge *Christ in Glory* painting by Moira Forsyth. (Author's collection)

Inside, most of the décor was produced by parishioners – even the thirty-two stained-glass windows designed by Gordon Forsyth are the work of younger members of the congregation.

Gordon Forsyth, the superintendent of Burslem School of Art, at the Wedgwood Memorial Institute granted fifty young people free art classes run by himself to make and decorate the windows. Forsyth also painted the ceiling panels – with the coats of arms of both the Pope and the Archbishop of Birmingham – and some of the church's murals. However, it was his daughter Moira who was the main artist, creating the huge *Christ in Glory* ceiling painting and *Christ Pantocrator* in the apse. She later became one of the finest stained-glass window producers in the country.

St Joseph's was completed in 1927 at a cost of £14,600 paid for by subscriptions and church collection. It was known as the 'Church of the Genuflections' in Arnold Bennett's novel *Clayhanger*.

11. CHEADLE, ST GILES' ROMAN CATHOLIC CHURCH

St Giles' Catholic Church, dedicated to the town's medieval patron saint, is often described as 'Pugin's Gem' and enjoys a national reputation amongst devotees of Victorian Gothic architecture, though in the early 1820s Fr William Wareing had

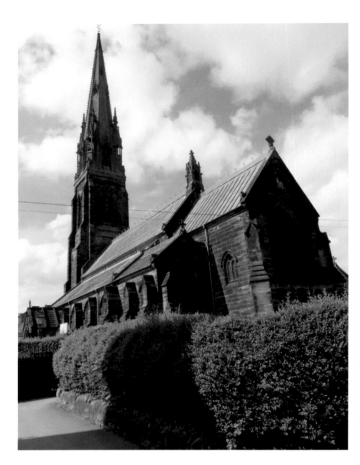

St Giles' Catholic
Church, Cheadle,
designed by
A. W. N. Pugin to
achieve a perfect height
to width ratio. (Author's
collection)

established a Catholic mission in Cheadle's Charles Street with a small chapel in a
private house.

The new church was planned by Augustus Pugin in the autumn of 1840 and
working with almost unlimited funds from his patron John Talbot, 16th Earl of
Shrewsbury, he was to achieve the perfect width to height ratio. In 1841 the site
was marked out and the building aligned to give the best effect from the street.
Twelve months later, the walls were up to arch height with the tower and spire
added in 1844. As far as possible Lord Shrewsbury wanted St Giles' to be a local
product and most of the red and white 'Hollington' type sandstone was quarried
at Counslow Hill between Cheadle and Alton. The oak and elm came from the
Alton estate. Two years on and the impressive interior decoration was completed,
but by the time of consecration, on Monday 31 August and Tuesday 1 September
1846 by Bishop Wiseman, the Earl's funds had diminished, and he never again
financed such an ambitious project.

Inside, the church is a magnificent wealth of colour; painted decoration covers
every part of the walls, ceiling and pillars and the reredos, pulpit, rood screen
and font are all Pugin's originals. The chancel and adjoining chapel of the Blessed

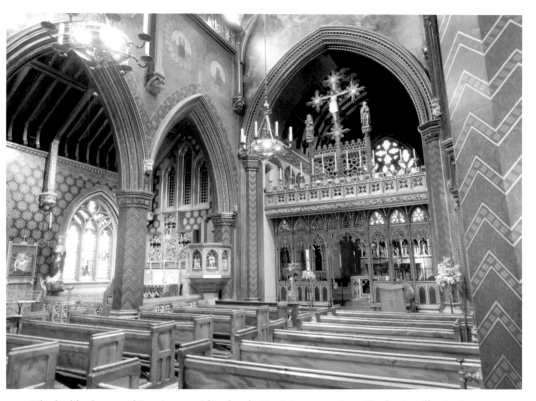

The highly decorated interior considered to be Pugin's masterpiece. (Author's collection)

Sacrament are paved with encaustic tiles by Herbert Minton, decorated with floriated crosses, 'Agnus Dei' and 'Sanctus' motifs and were the first Minton floors of their type in Europe. The 200-foot tower, the town's tallest building, houses a 14wt ring of bells and outside, the west door is guarded by rampant lions. Pugin himself referred to St Giles' as 'Cheadle, perfect Cheadle – consolation in all my afflictions'.

12. CHECKLEY, ST MARY AND ALL SAINTS ANGLICAN CHURCH
St Mary and All Saints is built of yellow sandstone and was consecrated in 1196 but underwent rebuilding in the fourteenth century when the chancel was replaced and the tower extended, followed by work in the fifteenth century and substantial rebuilding in the seventeenth century. Inside the church lies the tomb of Abbot Chauner, the last Abbot of nearby Cistercian Croxton Abbey, alongside that of Geoffrey and Margaret Foljambe, the post-Reformation owners of Croxton's lands. Interestingly, the east window is a rare example of fourteenth-century Flemish painted glass, which predates stained glass by some twenty years. The drum-shaped font with a lamb – though some say it's a donkey – carving is even earlier at *c*. AD 870. In the tower a 12cwt ring of six bells were originally hung from an oak wooden Elizabethan frame said to have been made from ship's

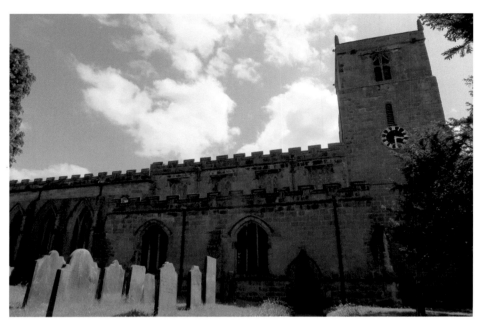

St Mary and All Saints, Checkley. (Author's collection)

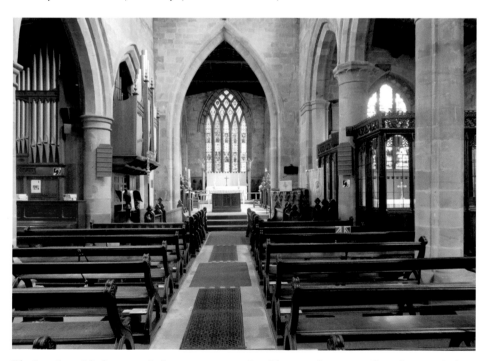

The interior with the east window, a rare example of fourteenth-century Flemish painted glass, predating stained glass by some twenty years. (Author's collection)

The *c.* 870 drum-shaped font with lamb or perhaps donkey carving. (Author's collection)

timbers. The bells were rehung in a new steel one in 2016 – the oak frame is conserved in the tower.

Outside, positioned on the wall to the right of the porch is a rare example of a 'Mass Dial' sundial to inform parishioners of Mass time. Also, the south wall buttresses bear deep-grooved scars thought to have been made by fourteenth-century archers sharpening their arrowheads before compulsory archery practice. Close by stand three Saxon preaching crosses from the ninth century known as 'The Three Bishops'. They are thought to represent three bishops killed in a battle between the Saxons and Danes half a mile away at Deadman's Green.

13. COVEN, METHODIST CHURCH

Coven Wesleyan Methodist chapel was first registered as a place of worship in 1826, making it one of the county's oldest Methodist chapels in continual use.

John Smith senior was a tenant farmer and blacksmith living at Three Hammers Farm – now a golf complex – with his wife Ann and children John junior, Joseph and Sarah. Later, John junior became a lock maker and the local maltster with enough income to purchase some land and a cottage in Lawn Lane. He donated a plot next to his cottage for a Wesleyan chapel to be built, which was opened in 1828.

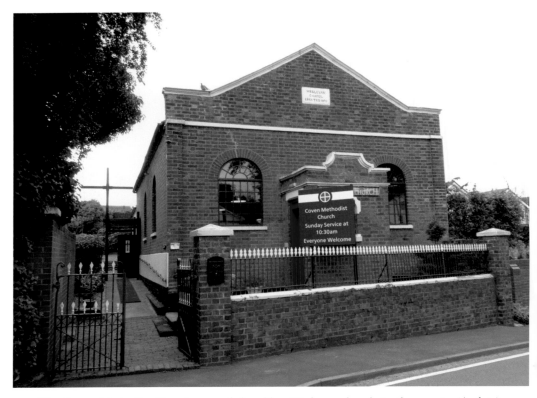

The Coven Methodist Church, one of the oldest Wesleyan chapels in the county. (Author's collection)

Interestingly, for the minister to gain access to the chapel he first had to pass through John Smith's cottage.

The chapel was replaced by a larger building at a cost of £340. It could accommodate 200 people and was opened on Tuesday 24 September 1839 by Revd G. B. MacDonald of Birmingham. It was described as 'a small, neat Wesleyan chapel' and John Smith was heard to preach at both the former and the new chapel. John went on to construct the village foundry next to the chapel in 1860 where he manufactured both stationary and locomotive steam engines and where a Sunday school was held in the loft above the machine shop. John Smith died on 2 February 1879, and is buried in Coven churchyard.

St Paul's, incidentally, was not consecrated until 1857. The foundation stones for a new schoolroom on the opposite side of Lawn Lane were laid on 12 July 1924, and from here the villagers collected their ration books in the Second World War. It was demolished in 2012 and the land sold to help finance extensive alterations to the chapel with the communion table moved to the opposite wall and an extension added to the rear incorporating modern facilities.

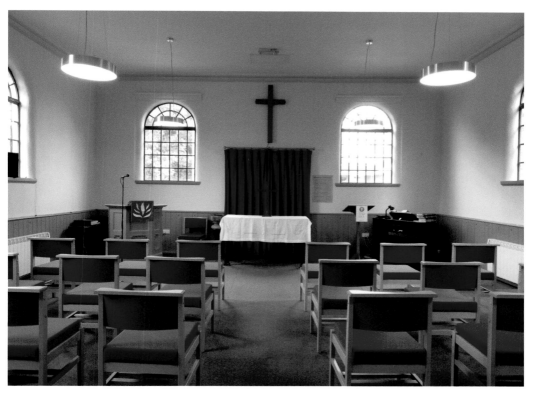

The refurbished chapel interior. (Author's collection)

14. CRESSWELL, ST MARY'S ROMAN CATHOLIC CHURCH

St Marys Catholic Church was described in the *Catholic Magazine* of 1834 as 'The mission of Painsley and Cresswell, formerly called the Draycott Mission, extended over a large district and was the mother church of the whole of North Staffs.'

Following the Act of 1791, which enabled Catholics to own places of worship on provision they were registered, Fr James Tasker either built or obtained a house in Cresswell where he opened a small chapel in an adjacent farm building at the rear of the property.

In 1816 Lady Stourton of the Draycott Estate commissioned a new church to be erected alongside the original one at a cost of £800 and it is said that the priest Fr Thomas Baddeley built it with his own hands. Fr Thomas also set up a mini seminary in the house, training several men to become priests.

By 1851 the church needed some repairs, and the gallery and rood screen (now removed) were constructed. It reopened on 22 November 1851 with a Mass celebrated by Bishop Ullathorpe of Birmingham. St Mary's also has a Pugin window in memory of Lady Stourton and the High Altar was blessed on 18 July 1935, a gift from an anonymous former parishioner.

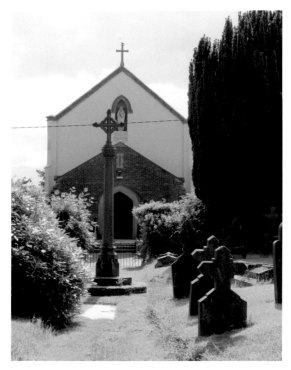

Left: St Mary's Catholic Church, Cresswell, which can claim to be a Mother Church of Roman Catholic North Staffordshire. (Author's collection)

Below: Interior of the church. (Author's collection)

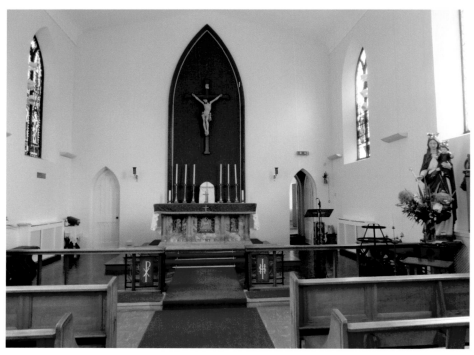

Amongst the church artefacts are some medieval chasubles discovered hidden in or behind a chimney at neighbouring Rookery Farm in the nineteenth century. They are thought to have been rescued from a former monastery or church and concealed at the Reformation.

St Mary's remains one of the oldest Catholic public chapels of worship in the diocese.

15. ECCLESHALL, HOLY TRINITY ANGLICAN CHURCH

Grade I listed Holy Trinity has the distinction of being the last resting place of five Bishops of Lichfield. Eccleshall had been home to the bishops since Saxon times when the estate was granted to St Chad, first Bishop of Lichfield. A small Saxon church was destroyed in 1010 by the Danes who set fire to the town and castle. Then in 1090 Elias de Janstonice, Norman prebendary of Eccleshall, rebuilt the original church, dedicating it to the Holy Trinity. The present church dates from the time of Bishop Hugo de Nonant, 1189, with the chancel, arcades and tower mainly thirteenth century. The aisles were rebuilt in the fifteenth century. Bishop Walter Langton commissioned the castle as his residence in 1305.

Later, the Civil War saw Cromwell's soldiers garrisoned in Eccleshall church when Royalists took the town in 1643 and besieged the building. They were

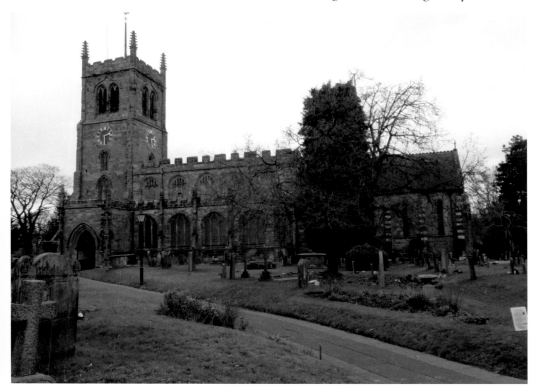

Holy Trinity Parish Church, Eccleshall, the burial place of five bishops of Lichfield. (Author's collection)

defeated when Parliamentarian reinforcements arrived from Stafford and captured the castle before destroying it. The castle was subsequently rebuilt and served as the Bishop's Manor until the nineteenth century.

Holy Trinity was restored by George Edmund Street in 1866–9. He reconstructed the north wall, so widening the north aisle by 4 feet, and designed the east end of the chancel. New oak pews replaced those of box design, while at the west end a baptistry and choir vestry were built on opposite sides of the 94-foot (29-metre) stone tower, home to a 10cwt ring of eight bells. Above, the stone pinnacles were an addition to honour Queen Victoria's Diamond Jubilee in 1897. The 1898 reredos is by Basil Champneys and on the south side of the chancel is the Bishop's seat. To the north side is the tomb of Bishop William Overton (d. 1609 aged eighty-four), also a former vicar of Eccleshall, depicted with his two wives and known as the 'Glass Bishop' due to his introduction of the glass industry to the area. He was described as 'A man of hard avaricious nature.' In the chancel's north-east corner lies the tomb of Bishop James Bowstead whose untimely death aged forty-two in 1843 was due to falling off his horse.

Two more bishops are interred in Holy Trinity. Bishop Richard Sampson, Chaplain to King Henry VIII, died in 1554 and is entombed in the old baptistry to the south of the tower. Bishop Thomas Bentham died in 1578 and lies in the choir vestry. He was dismissed by Queen Mary for 'forward and malapert zeal against the Catholic religion' during the reign of Edward VI.

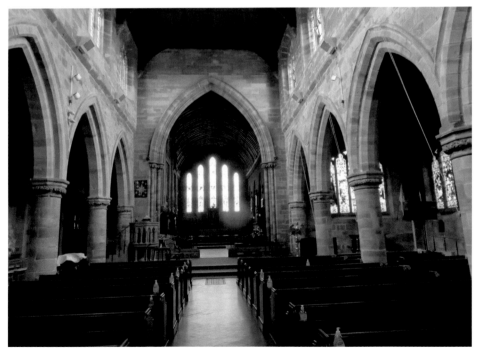

Looking towards the chancel with the Basil Champneys reredos and the Bishop's seat to the right. (Author's collection)

Outside is the grave of Bishop John Lonsdale who, after presiding over a diocesan meeting, died in his chair immediately afterwards in 1867 but not before he'd ordained 646 priests and 567 deacons at Holy Trinity. Also, to be found are two fragments of a Saxon cross carved with a figure which some claim to be St Chad.

16. ENVILLE, ST MARY THE VIRGIN ANGLICAN CHURCH

Enville's red-sandstone church has a strong connection with the Grey family whose Tudor relative Lady Jane was Queen for nine days in 1553. It sits on a spur of land where the ancient village was said to have been located and to the south of the church is Enville Hall. A minor branch of the Grey family of Bradgate Hall moved from Leicestershire to Staffordshire in the fifteenth century and through marriage gained the manor of Enville where Thomas Grey built his new house in the 1530s. The family rose to prominence in 1620 when the 2nd Baron Grey of Groby married Ann Cecil of Stanford and subsequently became Earl of Stanford in 1628. On his death the title passed to his cousin Harry of Enville whereupon his son, also named Harry, inherited the title as 4th Earl of Stanford and made Enville Hall the family's main residence.

The church of St Mary the Virgin's nave dates to *c.* 1100 with the transitional chancel built by Roger de Birmingham, parish priest from 1258 to 1346. While the

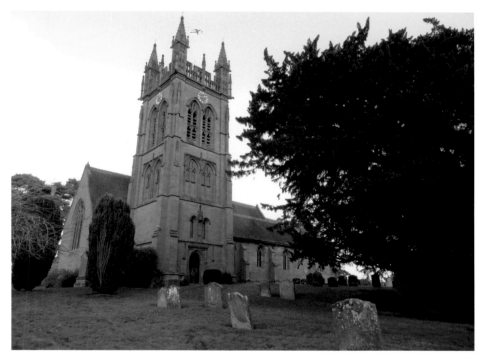

The church of St Mary the Virgin, Enville. The tower's elaborate crown is based on Gloucester Cathedral. (Author's collection)

south aisle is twelfth century, the north aisle is thirteenth century, built along with the chancel. Then in 1332/3 a chantry chapel was founded in the north aisle – now the vestry – by Philp de Lutteley of Lutteley Hall with a licence from King Edward III where a priest was requested to say a daily Mass for 'God and St Mary His Mother'. The last chantry priest was William Spoyle (Spittell) who was granted an annual pension of £6 in 1553.

In 1749 the chancel was renovated and the south porch added or rebuilt. The Grey family, by now Earls of Stamford and Warrington, had their family pew, known as the 'Stamford pew', constructed at the west end of the church and here a stone coffin lid was discovered with the inscription 'Rogerus de Morf' – the name 'Morfe' still survives as part of the parish.

St Mary's was enlarged and restored by George Gilbert Scott in 1871–4. A faculty was dated 16 June 1871 for the demolition of the nave's west end; the building of a new chancel and east window; removal of the 1820 north aisle gallery; a new pulpit, font and reredos; altar rails (the rood screen dates from 1884 in memory of the 7th Earl of Stamford); and unusually, the tower housing a 14cwt ring of eight bells was rebuilt with an intricate crown based on that of Gloucester Cathedral. The total cost was £5242.17.6d (£5242. 87 1/2p.). Meanwhile, the tomb of Thomas Grey (d. 1559) and his wife Ann (d. 1586), surrounded by their thirteen children, was removed from the north side of the chancel to lie under the east window in the south aisle. The choir stalls too, and possibly the four fifteenth-century misericords (said to have come from Buildwas Abbey granted to Edward Grey in July 1537 following the Reformation) on either side of the stalls were positioned in the chancel.

It was during this work that that the tomb of priest Roger de Birmingham, recumbent under an arch in the chancel, was opened to find traces of vestments on his bones and the soles of his shoes still in perfect condition. Next to his right hand lay a chalice and paten.

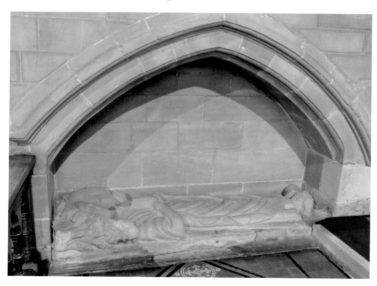

The thirteenth-century recumbent tomb of Priest Roger de Birmingham in the chancel. (Author's collection)

17. GNOSALL, ST LAWRENCE ANGLICAN CHURCH

Some 1,000–1,200 years ago an early Saxon collegiate chapel stood on the sandstone outcrop looking across Doley Brook at Gnosall. Situated at what is now the crossing under the present-day central tower, the chapel was served by four clerics sharing a nearby dwelling. Supported financially by four 'Prebendary Manors' – Chilternhalle, Morehalle, Sukarshalle and Merehalle – all owned by Lichfield Cathedral, the 'Four Clerks' became known as the 'Prebends of Gnosall'.

Following the Conquest, a new cruciform-shaped church was built with twelfth-century rounded arches supporting the central tower. In the thirteenth century the north transept was rebuilt with a double lancet window in the end wall, and the tower – today with a 14cwt ring of eight bells – was elevated to 72 feet (22 m) in the fifteenth century with a new clerestory added. It was then that the will of Roger de Pershale, Lord of Knightly, records that St Lawrence's was referred to as 'The Blessed Peter and Paul of Gnosall'. Later, *c.* 1500 saw the construction of the Lady Chapel to the south side of the chancel.

The late nineteenth-century renovations involved the scraping of wall plaster – which unfortunately destroyed many of the underlying medieval paintings – and the removal of the nineteenth-century gallery, together with the post-Reformation box pews and three-decker pulpit.

St Lawrence's was reopened on 30 November 1888 by the Bishop of Lichfield. A south doorway porch, designed by Charles Lynam in 1893, was subsequently added.

Revd John Till preached at Gnosall for the first time in 1845 and was still preaching there in the early twentieth century. He died on 18 July 1901 and is buried in the churchyard.

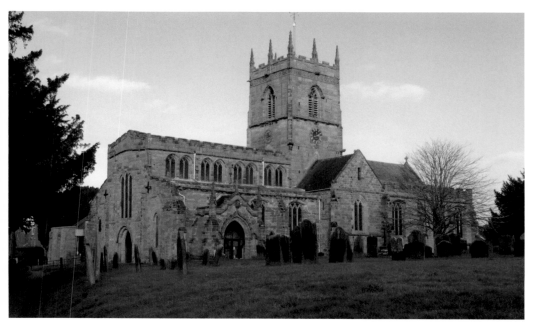

The church of St Lawrence, Gnosall, a one-time Saxon collegiate and minster. (Author's collection)

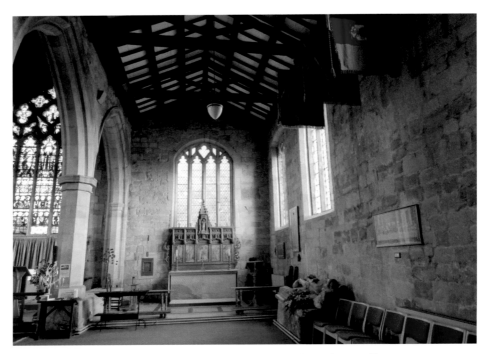

The Lady Chapel, built *c*. 1500, to the south of the chancel. (Author's collection)

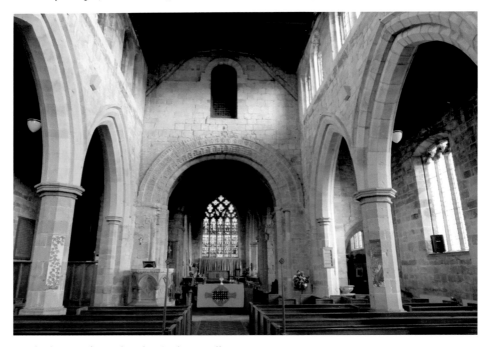

Inside the cruciform church. (Author's collection)

18. GREAT HAYWOOD, ST JOHN'S CATHOLIC CHURCH

St John's Church had its beginnings in Tixall as the Cliffords' family chapel. However, its roots are a great deal older. As early as the twelfth century the Aston family of Tixall owned the estate of Great Haywood and following the Reformation it became a safe house for priests along with many Catholic workers who were employed on the estate. This practice continued when the heiress Barbara Aston married Thomas Clifford of Chudleigh in 1762.

Thomas set about rebuilding the old hall which had always housed a chapel to include a new one, disguised as a dining room. His son Thomas Hugh inherited the estate in 1791, the same year as the English Relief Act was passed permitting Catholics to practice openly, and the chapel became a registered place of worship. In turn, Thomas's seventeen-year-old son, Thomas Aston Clifford Constable, inherited in February 1823. He refurbished the hall and built new stables along with a private Tudor Gothic-style chapel in the grounds, designed by Joseph Ireland in 1827–29 at a cost of nearly £19,000. At the east end was a large bay window which once graced the front of the original 1555 Tudor house. By 1833 Thomas was in serious debt and put the estate up for sale before moving to his Yorkshire property. All that is, except for the chapel and an acre of land at Great Haywood which was left to local parishioners. Eventually, in 1845 the land was sold to the Chetwynd Talbots of Ingestre and work began on moving the chapel piece by piece to Great Haywood where the first foundation stone was laid that year. Most of the work was done with local labourers and parishioners under the guidance of Henry Hale, builder of Walsall. Today, some marks and numbers can still be seen on stones inside the church indicating their relevant position. While the church was dismantled, moved and reconstructed, parishioners attended Mass in a hayloft over the barn at Tixall Farm.

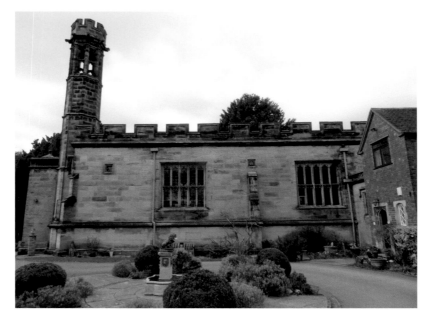

The present St John's Catholic Church, Great Heywood, moved from nearby Tixall and completed in 1846. (Author's collection)

Some of the mason's marks indicating the position of the stones for the rebuild. (Author's collection)

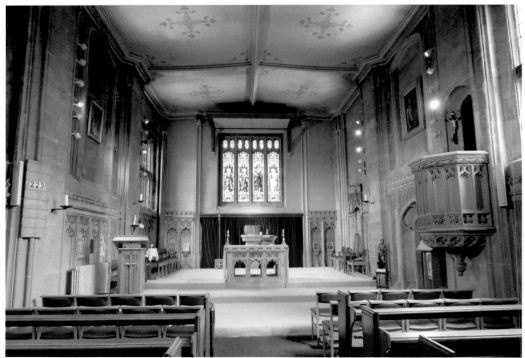

The interior of St John's Church. (Author's collection)

In 1846 the chapel was completed and dedicated as the parish church of St John the Baptist in October that year, though it is somewhat smaller than its former design. While most stone carvings are from the old chapel, the east wall is without the bay window, the southside has lost its side chapel and the bell tower now stands to the side of the main door as opposed to the centre. The bell was the first one cast in Ireland (John Murphy of Dublin) to be hung in an English Catholic church.

St John's was refurbished in 1979. Damp proofed, cleaned, and rewired, the altar rails were removed and the altar bought forward. The total cost was kept to around £20,200 as most of the necessary skills were provided by the parish with minimal outward assistance. It was consecrated on 23 June 1983 by the Archbishop of Birmingham Maurice Couve de Murville.

As for the Tudor east window, it was damaged in transportation and after spending some time as a garden ornament the stone was rescued and the remains are now in the church garden.

19. HALMEREND METHODIST CHURCH

The present Methodist church in Halmerend was built in 1867 as a Primitive Methodist chapel on the site of an earlier place of worship. In the 1830s Primitive Methodists held meetings in the village after their founder members Hugh Bourne and William Clowes preached there. By the early twentieth century the chapel had a mission to educate both children and adults at their Sunday school, teaching both literacy and religious instruction. At one point there were over 200 children at the Sunday school and their parents borrowed books from the church library.

The Primitive chapel played a vital role in north Staffordshire's worst mining disaster, at the nearby Minnie Pit, on Saturday 12 January 1918 when 155 men and boys plus one rescuer died. Many of the miners and their families were Methodists and a group of women were decorating the schoolroom in preparation for a party that evening when celebration turned to horror; the decorations were quickly removed.

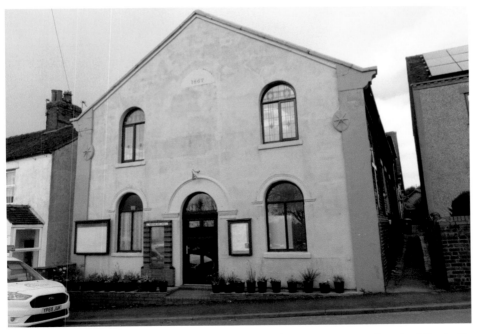

The Methodist Church, Halmerend, with the brass plaque commemorating the Minnie Pit disaster of 1918. (Author's collection)

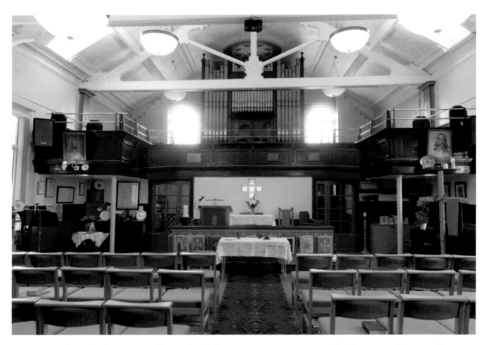

Inside the chapel where many funerals of the Minnie Pit victims took place. (Author's collection)

The chapel became a temporary mortuary for the victims, forty-eight of whom were boys under seventeen and many just fourteen years old. The women laid out their bodies and as more continued to be recovered, the chapel hosted funerals on an almost daily basis, creating sixty-seven widows and 132 dependants. Later, some of the public enquiries into the disaster were heard in the adjoining schoolroom.

Today, a brass plaque on the front wall of the church lists the names of all who died and two memorial stones are in the hall. One is in memory of the teachers and scholars of the Primitive Sunday school and the other in memory of the teachers and scholars of the Wesleyan Methodist church which stood on the corner of High Street and Wesley Place – rescued by Albert Lawton during its demolition.

20. HEDNESFORD, OUR LADY OF LOURDES CATHOLIC CHURCH

In the 1890s a chapel and school more akin to a wooden hut was built at Hill Top. Dedicated to St Joseph and St Philomena, it was served from Cannock until 1907 when Fr Patrick Boyle became the first parish priest.

Following a visit to the shrine at Lourdes, France, in 1913, he pledged to construct a replica at Hednesford but unfortunately Fr Boyle died before it was built. It was his successor, Fr Joseph Healey, who raised funds to purchase the present site in 1923, where Mr George Bernard Cox submitted plans for a Gothic Lourdes-style building which had to be modified in construction. Owing to the proximity of coal mining, both the foundations and the church are built of ferro concrete with the church faced in Portland stone. Builders Wilcock of Wolverhampton

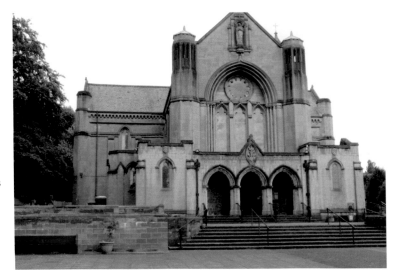

Our Lady of Lourdes
Catholic Church,
Hednesford, which
was planned to
replicate the church
at Lourdes, France.
(Author's collection)

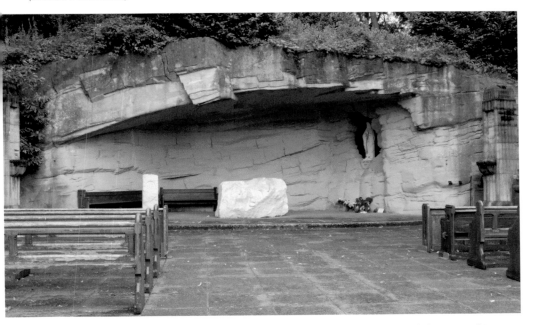

The grotto of Our Lady of Lourdes built in the church grounds as a copy of the original in
France. (Author's collection)

used over 1,500 tons of concrete and 150 tons of steel rods to lay the foundations
of mass concrete pillars, between which are vaults where giant adjustable jacks
can be applied to counteract any subsidence. On 12 September 1928 Archbishop
McIntyre laid the foundation stone and at a cost of over £50,000. The church was
opened by Archbishop Williams on 6 June 1934. At 120 feet long and 84 feet wide,

it was claimed to be the first 'earthquake-proof' building in the country. Inside, the High Altar sits underneath a Gothic baldacchino with the ceramic stations of the cross designed by Philip Lindsey Clark and outside, to the north-west of the church in extensive grounds, is a replica of the Lourdes Grotto completed in 1935, and from 1966 onwards it has hosted the annual diocesan pilgrimage.

21. ILAM, HOLY CROSS ANGLICAN CHURCH

St Bertram, also known as Bertelin, Bertellin and Barthelm, King of Mercia *c.* eighth century, was raised in a cave at nearby Wetton. Apparently, he travelled to Ireland where he married an Irish princess who on the way home gave birth to their child in a cave close to Wetton. While Bertram left them to search for food, wolves attacked and killed mother and baby. Distraught, he renounced his royal heritage to live as a hermit until his death. Bertram's grave in Holy Cross Church rapidly became a place of pilgrimage, as it is today.

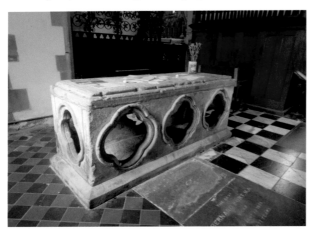

Left: The tomb of St Bertrum in his chapel at Holy Cross Church. (Author's collection)

Below: Holy Cross Church, Ilam, with the large Gothic-style mausoleum chapel to the north side. (Author's collection)

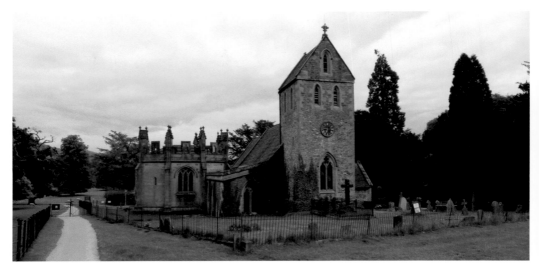

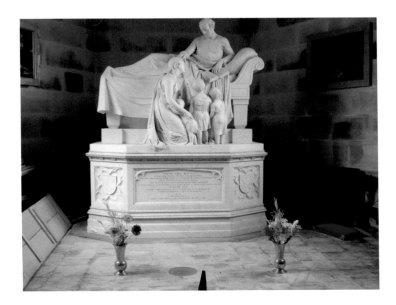

The chantry chapel
mausoleum with
the white marble
Gothic-style tomb
of David Pike Watts.
(Author's collection)

Holy Cross has its roots in Saxon times and the south wall has a blocked-up Saxon doorway. Until the nineteenth century the church stood in Ilam village; however, when Jesse Watts Russell built Ilam Hall in the 1820s he moved the village as it interfered with the view from his house, leaving the church standing alone.

The church was partly rebuilt in the Norman and Early English style with a thirteenth-century tower housing a 9cwt ring of five bells. The font, too, is Norman, with carved illustrations depicting St Bertram's life. The south chapel was added in 1618 by the Meverill family of Throwley Hall to house the thirteenth-century tomb of St Bertram. The largest extension is the Gothic-style chapel added to the north side in 1831 by Jesse Watts Russell as a mausoleum to his father-in-law, David Pike Watts, a wealthy London brewer and vintner (d. 1816). Designed by Francis Chantry, a grand white marble tomb portrays the deceased in a deathbed scene with his family.

Holy Cross underwent major restoration by Sir Gilbert Scott in 1855–6 when the east end was rebuilt along with the north arcade. Scott also designed much of the church furniture. Outside in the churchyard stand the remains of two carved Saxon crosses.

22. INGESTRE, ST MARY'S ANGLICAN CHURCH

St Mary's is the only church outside London attributed to Sir Christopher Wren. Much earlier, in the thirteenth century, a church was recorded when the Chetwynd family acquired Ingestre Manor by marriage in 1256. Initially a Chapel of Ease of St Mary's, Stafford, it was initiated by the Lord of the Manor under the Bishop's authority. Then, between 1485 and 1509 a new chapel, dedicated to St Erasmus Martyr (also known as St Elmo, d. AD 303), was built by William Chetwynd on the Waste of Ingestre and endowed with land to support a priest. Its fame quickly spread due to the healing properties of the adjacent salt spring frequented by the sick and lame who left their crutches on the walls and in 1535 gave offerings of

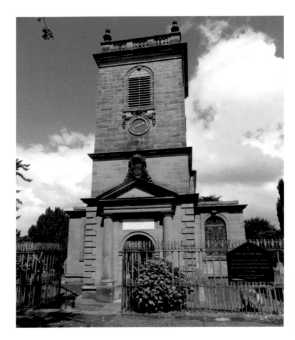

The Church of St Mary, Ingestre,
the only one outside of London
attributed to Sir Christopher Wren.
(Author's collection)

£6.13.4*d* (£6.67p). The chapel was valued for the first Act of Dissolution in 1536 at £10.16.8*d* (£10.84p); however, it remained until the Chantries Act of 1547 when St Erasmus's was seized by the Crown. Eventually the chapel was purchased by two speculators in 1549 who then sold it to Thomas Chetwynd, the founder's son and successor. Today, its exact location is unknown.

By 1671 the chapel was in a state of disrepair and Walter Chetwynd appealed to the Archbishop of Canterbury for permission to build a new church at his own expense as a memorial to his wife who had died in childbirth. The foundations were laid in 1673 and the church finished in 1676 with the design attributed to Sir Christopher Wren. Walter Chetwynd and Wren were close friends – both were members of the Royal Society. A drawing by Sir Christopher Wren titled 'Mr Chetwynd's Tower' is amongst the collection of Wren's drawings held in the Victoria and Albert Museum.

St Mary's is built in the Grecian style with Flanders Oak woodwork accredited to Grinling Gibbons, who also worked on Wren's St Paul's Cathedral, London. Some of the original stained glass from the old church survives in the armorial bearings featured in the roundels of the side windows. The Chetwynd family's deceased forebears were said to have been exhumed from St Erasmus's and reinterred under the sanctuary floor of the new church.

The consecration was held in August 1677 when the Bishop baptised a child, churched a new mother, celebrated a marriage and undertook a funeral all on the same day to demonstrate that St Mary's was not a Chetwynd family chapel but a parish church for the village.

It went on to become one of the first churches to have electric lighting installed in 1886.

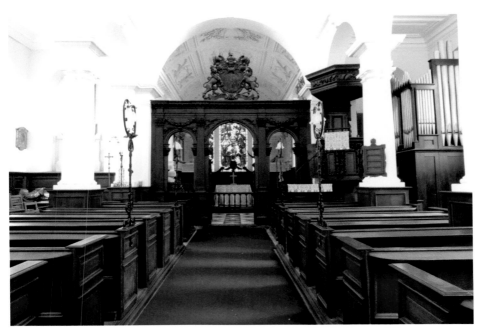

Inside St Mary's, where the fittings are largely original. (Author's collection)

The church fittings are mostly original and include the tomb of Lord Talbot, 18th Earl of Shrewsbury, and the Sanctuary window, which has two figures of St John as a memorial to the 19th Earl. The tower houses a 13cwt ring of six bells, some bearing the name and arms of Walter Chetwynd dated 1692. They were restored and rehung in 2006.

23. Lapley, All Saints Anglican Church
In the eleventh century the Benedictine priory of St Peter stood on the north side of the present All Saints Church and both were encircled with a moat.

Originally the church at Lapley was a Chapel of Ease from the Collegiate Church at Penkridge before Algar, Earl of Mercia presented Lapley together with other Staffordshire lands to the Abbey of Saint-Remi at Reims in memory of Burgheard, the Earl's third son who was returning from Rome when he fell ill and died at Rheims leaving a request to be buried there.

Typically, the Norman monasteries established cells with two monks and a prior on their distant estates to manage the land, and in 1086 there were just two Norman monks recorded at Lapley. Later, when King John lost Normandy in 1204, the Crown seized Lapley Priory only to return it to the monks after payment of a fine which was repeated in 1288 and 1325. The priory, like others who had their Mother House in France, came under increasing pressure during the Hundred Years' War (1337–1453) as they were seen to be financing the enemy. Lapley was eventually suppressed in 1414 and its lands transferred to the College of Tong on 15 June 1415. The adjoining church continued to serve the village.

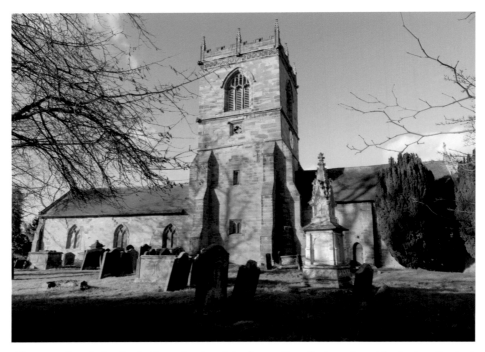

All Saints Church, Lapley, built on the site of the former Benedictine priory. (Author's collection)

All Saints has a large central tower housing a 10cwt ring of six bells, the base of which is Norman and the upper part fifteenth century. A twelfth-century chancel and a thirteenth-century nave are peculiarly aligned, while to the north and south of the tower additional supporting buttresses were added in 1637 with the names of Edward Beree and William Tonk – churchwardens of the time – inscribed on them.

During the Civil War both the church and hall were requisitioned by the Parliamentarians to garrison seventy men. Then, when Catholic Lord of the Manor Walter Brooke was succeeded by fellow Catholic Thomas Petre the Puritan vicar was appalled at the frivolity of the 1655 August Wakes and duly wrote to the County Justices urging them to prohibit church wakes. A few months later at Staffordshire Quarter Sessions thirteen Morris dancers were prosecuted for dancing at Lapley.

The church was repaired and improved in 1723 and 1770, but by 1855 more substantial work was required, particularly on the tower. It was dedicated by Bishop John Lonsdale of Lichfield in 1857.

Inside All Saints is a medieval Dutch font with carved Biblical scenes, probably brought to Lapley by a monk and later removed by Cromwellians. It was discovered *c.* 1850 in a local farmyard being used as a drinking trough and was returned to the church and restored with a new shaft and base. Adjacent to the sedilia are the remains of a medieval tiled floor while on the nave's north wall is part of a similar wall painting.

The interior
of All Saints
Church.
(Author's
collection)

24. LEEK, ST EDWARD'S ANGLICAN CHURCH

Although St Edward's Church was originally built during the reign of Edward the
Confessor (1042–66), today it is of particular interest to devotees of the Victorian
period.

Leek was initially a parish with a rector until 1215 when Lord of the Manor
Ranulph de Blundeville, 6th Earl of Chester, founded the nearby Cistercian Abbey
of Dieulacres and presented the manor and church of Leek to the abbey. By 1223
the Bishop had sequestered St Edward's to the monastery subject to the Abbot
appointing a vicar at Leek. The church was worth £28 in 1246. Along with most
of the town St Edward's was destroyed in the Great Fire of Leek on 10 June 1297
and rebuilt some twenty years later by Abbot Robert Burgillon.

While much of the fourteenth-century building remains, the tower – with an
18.5cwt ring of ten bells – and the north and south transepts with their impressive
rose windows and the south porch were added in the seventeenth century, and the
eight stone pinnacles placed on the tower in 1816. The major restorations though
took place in 1839 and 1865–7.

In 1839, Ewan Christian, architect to the Lichfield Diocesan Building Society,
restored the timber nave roof where each crossbeam reportedly came from a
different oak tree. In 1865–7, George Edward Street completely rebuilt and
extended the chancel with a wagon-shaped roof. He was also responsible for
designing the new reredos, stalls, organ screen lectern and pulpit, with the wood
carvings by Thomas Earl.

Inside at the west end is an unusually tiered and deep gallery and fine examples
of work from the Leek School of Embroidery (established 1879–80) are kept by
the church.

St Edward's Parish Church, Leek, at one time in the possession of the nearby Cistercian Abbey of Dieulacres. (Author's collection)

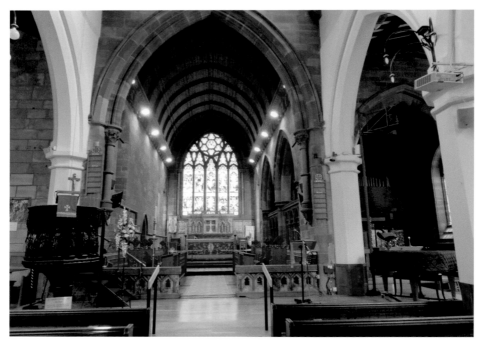

Inside the church with the waggon-shaped roof, which is of particular interest to enthusiasts of the Victorian era. (Author's collection)

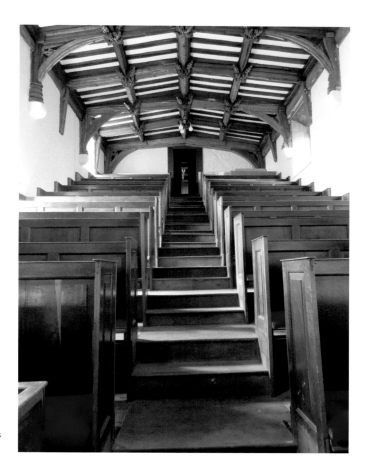

The unusual tiered and deep west end gallery with carved roof beams. (Author's collection)

Outside are two medieval crosses from the seventh to the eleventh centuries; one is cylindrical and stands 10–11 feet high, said to have been placed by St Wilfred, and the second is 8 feet high. An old saying refers to the larger one: 'When the churchyard cross shall disappear Leek town will not last another year.'

An interesting anecdote is the phenomenon of the 'double sunset' visible from St Edward's churchyard. At midsummer crowds gather in 'Doctor's Corner' – eight doctors are buried there – at the north-east corner of the churchyard to watch the sun set behind Bosley Cloud only to reappear and set once more.

25. LEEK, ST MARY'S CATHOLIC CHURCH

In 1813–4 Leek was a temporary home to some French prisoners of the Napoleonic Wars and to care for their spiritual needs émigré priest Father Louis Gerard came from Cobridge to a room in Pickwood Street to say Mass for them and several Irish silk weavers before moving to a garret in King's Street owned by solicitor William Ward. Later, Fr James Jeffries arrived from Cheadle and built a chapel in Fountain Street dedicated to St Mary in 1828/9. A further plot of land in Fountain Street was purchased in 1860 for a new church and school designed

by architect William Sugden, built 1863–4, at a cost of £700 with a contribution from the Earl of Shrewsbury.

The present church was built on land bought in 1860 for £400 by the very wealthy convert and former Anglican minister John H. Sperling who commissioned architect Albert Vicars and bore most of the construction costs himself. His son Alfred Sperling was parish priest at St Mary's for some forty years from the 1880s to 1920s.

The foundation stone was laid by Bishop Islay of Birmingham on 15 October 1885. The church was constructed by Barker and Sons of Handsworth in the Gothic style at a cost of £12,000. Bishop Islay returned to open the church on 13 May 1887.

While the tower was designed to hold six bells there are only two dated 1887.

Inside, the east window was a gift from Elizabeth Bermingham. Another window is a memorial to (later) Monsignor Alfred Sperling following his death in 1923 and a further one is to Mother Mary Joseph, head of St Mary's school for forty-nine years. The forward altar of 1997 incorporates the frontal of a much older one, a solid oak mensa with bronze legs discovered in a Staffordshire farmhouse. The pipe organ came from Ball Haye Methodist Chapel after it closed in 2002.

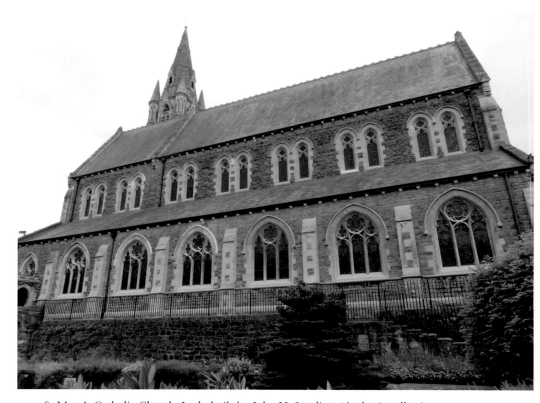

St Mary's Catholic Church, Leek, built by John H. Sperling. (Author's collection)

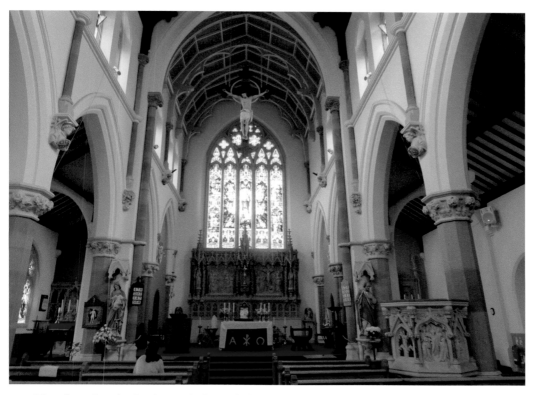

The chancel with the forward altar which incorporates the frontal of a much older one discovered in a Staffordshire farmhouse. (Author's collection)

26. LEEK, TRINITY CHURCH, UNITED REFORMED/METHODIST CHURCH

Trinity church began as a Congregational chapel designed remarkably in the Decorated Gothic style with a 130-foot-high tower and proportioned spire at the north-west corner.

A deed shows that the land was purchased in 1683 and a Dissenting Meeting House stood on the site in Derby Street in 1695, which later suffered damage by rioters on 'Fair Day' 1715.

Methodism came to Leek in 1754 with Thomas Hanby who first preached in the Blacks Head Inn yard. In 1784 the first chapel was built at Mount Pleasant in Clerk Bank.

The present Trinity church was designed by William Sugden and constructed on the site of a previous 1793 chapel. The corner stone was laid on Monday 7 July 1862 and it was opened on Tuesday 22 December 1863. It was dedicated by the pastor. Sugden, with his son and partner William Larner Sugden, dominated most of the architecture in Leek *c.* 1860–1900.

Nonconformists often associated Gothic architecture with Catholicism and although inside the building lacks aisles and a nave in line with other chapels, nevertheless its design bears the influence of A. W. Pugin's Victorian Gothic revival.

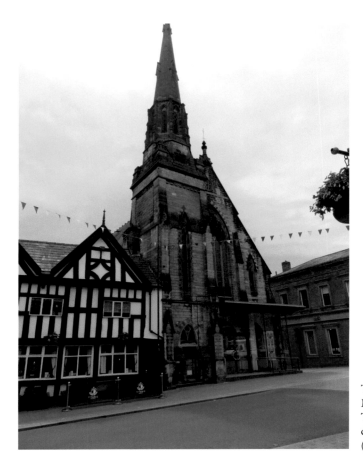

The unusual Gothic-style
Methodist/United Reformed
Trinity Church, Leek,
designed by William Sugden.
(Author's collection)

In 1972 the English Congregational and Presbyterian churches joined together to form the United Reformed Church and then in 1977 the URC and Leek Central Methodists came together at Trinity church with Methodist and URC ministers selected on an alternative basis.

The church underwent extensive refurbishment in 1980–1 when the front was opened to incorporate a window onto Derby Street.

27. LICHFIELD, ANGLICAN CATHEDRAL OF ST MARY AND ST CHAD

Lichfield Cathedral is the only three-spired medieval cathedral in the country and the spires are known as the 'Ladies of the Vale'.

Its origins lie in the formation of the Mercia diocese in AD 656 when St Chad moved the diocesan seat from Repton to Lichfield. Then in 669 he arrived in Lichfield to construct the first church in the diocese, on the far side of Stowe Pool. St Chad died and was buried at Stowe in 672.

Some twenty-eight years after his death Bishop Hedda built a new wooden Saxon church on the present cathedral site and translated St Chad's remains there. Dedicated to St Mary, it was consecrated on Christmas Day 700. The shrine

rapidly became a place of pilgrimage and following the Conquest the church was rebuilt of stone by the Normans in 1085. That too was replaced when work began in 1195 on constructing the current Gothic dark red-sandstone building. By 1200 the choir was built, the transepts between 1220 and 1240, followed by the completion of the Chapter House in 1249; the nave was started in 1260. In the fourteenth century Bishop Walter Langton (Bishop from 1296 to 1321) paid for the final work on the Lady Chapel and spent £2,000 on the decorated shrine of St Chad. The cathedral was completed *c.* 1340. Possibly three of the architects were William FitzThomas and Thomas Wallace, *c.* 1265–93, and William Franceys (William de Eyton), the Bishop's mason in 1312–13. Earlier Bishop Roger de Clinton (Bishop 1129–48) had surrounded the close with a wall before Langton strengthened and crenelated it, and constructed the cloisters and Bishop's Palace – the remains of which are in the palace garden.

For a short time Lichfield had an Archbishop, when King Offa of Mercia created his own Archbishopric in 787 to rival Canterbury. However, it was only to last sixteen years and was weakened further when the Bishop's seat moved to Chester. Twenty years later Bishop Robert de Lymesey transferred to Coventry, taking the

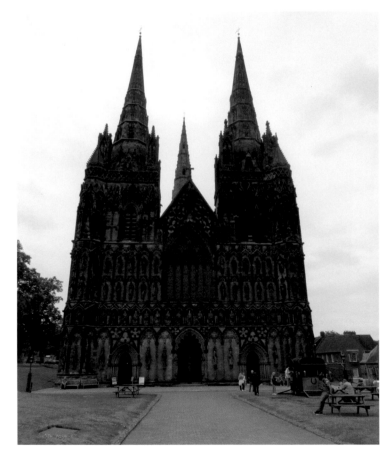

Lichfield Cathedral of St Mary and St Chad, the country's only medieval cathedral with three spires. (Author's collection)

title Bishop of Coventry and adding Lichfield later, but in 1660 it took precedence when the names were transposed and the diocese became that of Lichfield and Coventry. The Bishopric of Lichfield was established in 1836.

For hundreds of years the devout came to visit the tomb of St Chad to the extent that it was one of the three most significant medieval sites of pilgrimage in the country, on a parr with Canterbury and Walsingham until the Reformation when the shrine was destroyed in 1538. St Chad's relics, though, were secretly taken from the cathedral by Canon Arthur Dudley and remained hidden for many years. Today, they lie above the High Altar in St Chad's Roman Catholic Cathedral, Birmingham. Lichfield Cathedral's links with its patron saint, however, are not forgotten. In 2003 the beautifully carved eighth-century limestone angel known as the 'Lichfield Angel' was discovered during excavation work. It is thought to represent the Angel Gabriel and to have been part of St Chad's tomb chest. The cathedral also cares for the eighth-century 'Lichfield Gospels' or 'St Chad's Gospel'. Dated to 730, it predates the 'Book of Kells' and has some of the earliest-known illustrations of written Welsh.

In 2022 plans to recreate St Chad's shrine in the cathedral's Lady Chapel began with the assistance of the Catholic Archdiocese of Birmingham who are translating a portion of the relics from their present resting place at Birmingham Cathedral back to Lichfield.

During the Civil War Lichfield Cathedral was besieged three times, firstly by Parliamentarians who accepted the Royalists' surrender on 4 March 1643. Then a

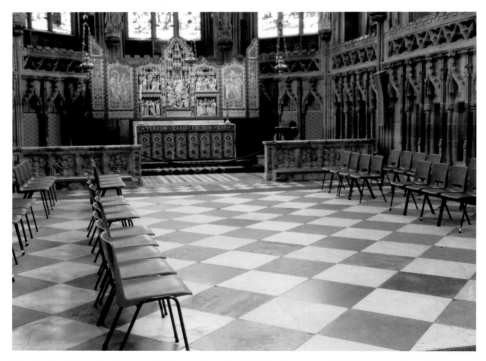

The Lady Chapel where pre-Reformation St Chad's shrine stood before the altar. There are plans to recreate it. (Author's collection)

month later on 8 April Prince Rupert's Royalist army laid siege to the Roundheads. It was during this onslaught that his troops detonated what is considered to be the first explosive mine used in the country. The Parliamentarians surrendered on 21 April 1643 but three years later they returned and after a three-month siege once again took the Royalists' surrender in July 1646. Lichfield was the first cathedral to be taken by Cromwell.

Cromwell's New Model Army used the cathedral as a barracks and stables while destroying medieval wood and stone carvings, defacing monuments, stripping lead from the roofs and razing the central tower. A report of 1649 read that 'A great part of the roof is uncovered'. Any remaining lead was taken by a 1651 Parliamentary Order, leaving only the vestry and Chapter House with a roof at the Restoration of the Monarchy in 1660. Understandably, the first service to be held under King Charles II was in the Chapter House.

Bishop John Hacket began work renovating the cathedral, which took seven years, following his appointment in December 1661. The cathedral was fully restored by Sir George Gilbert Scott in the nineteenth century. Unfortunately during this renovation, on 11 July 1878 Henry Williams died falling from the tower where he was working. He was buried where he had landed. Today the tower has a 31cwt ring of ten bells.

More recently, on Friday 15 January 2021 Lichfield Cathedral became the country's first religious building to host a covid vaccination centre.

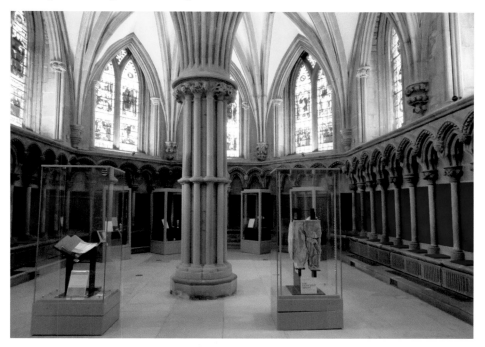

The Chapter House where the first service to be held following the restoration of King Charles II took place and where the 'Lichfield Angel' is displayed to the right of the picture. (Author's collection)

28. MUCKLESTONE, ST MARY'S ANGLICAN CHURCH

A church has stood on the site of St Mary's from at least the eleventh century and possibly before the Norman Conquest. Apart from the *c.* thirteenth/fourteenth-century tower, it was rebuilt in 1789 and again in 1883, in the decorated style by Lynam and Rickman of Stoke-on-Trent.

The church is best known for its association with the Battle of Blore Heath that took place on 23 September 1459. According to legend, Queen Margaret of Anjou observed the battle from the church tower. It was the first major battle in the Wars of the Roses between Lancastrian King Henry VI and Richard Duke of York.

Queen Margaret had instructed Lord Audley, with his 10,000 troops, to intercept the Yorkist Earl of Salisbury's 5,000 soldiers as they marched from Yorkshire to Ludlow. However, things did not go to plan when Lord Audley was killed after crossing Hemp Mill Brook and his army defeated.

To avoid capture the Queen recruited William Skelhorn, the local blacksmith, to reverse the shoes on her horse and so conceal the direction of her getaway as she fled to Eccleshall. Unfortunately for Skelhorn he was caught and executed on his anvil, which now sits in the churchyard opposite the old smithy.

St Mary's has thirteen stained-glass windows by C. E. Kempe, one of which at the tower base depicts Queen Margaret and King Henry VI and the Royalists' defeat at Blore Heath.

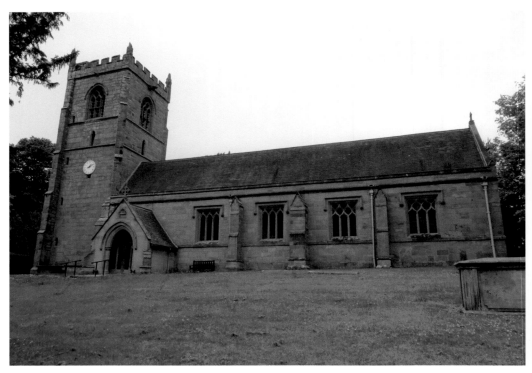

St Mary's Church, Mucklestone, where, according to legend, Queen Margaret of Anjou watched the Battle of Blore Heath from the tower in 1459. (Author's collection)

The anvil on which blacksmith William Skelhorn was executed for deceit in helping Queen Margaret escape. (Author's collection)

29. NEWCASTLE-UNDER-LYME, ST GILES' ANGLICAN CHURCH

While there has been a church here at Newcastle from *c.* 1180, it was originally a dependent of Trentham Priory and then before 1297 was transferred to Stoke where it continued under their jurisdiction until the formation of the Newcastle Rectory in 1807.

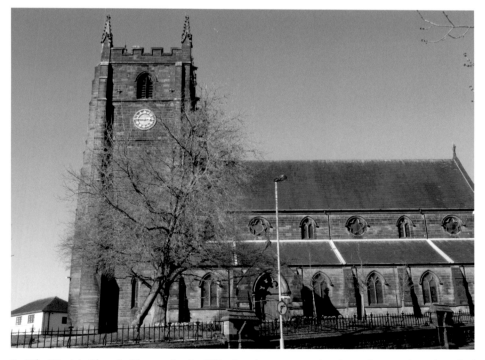

St Giles' Parish Church, Newcastle, the fifth church to occupy the site and a one-time chapel of Trentham and later of Stoke. (Author's collection)

St Giles' thirteenth-century red-sandstone tower is the town's oldest building and stands 110 feet high. It has a 16cwt ring of twelve bells, the first such ring in the county. The present church is perhaps the fifth one to be built on the site, demonstrated by the marks from previous roofs visible on the tower wall inside the church. The original twelfth-century building was replaced *c*. 1290 by one of Early English design in red sandstone with a tower, the base of which still stands. In the fourteenth century a third church was constructed and the tower raised.

In July 1715 rioters set fire to the nearby nonconformist chapel without considering the prevailing wind direction. Sparks were carried to St Giles', so condemning it to 'decay and dilapidation'. In 1720–1 it was completely rebuilt, with galleries and no central aisle, at a cost of £1,555. It was opened on 5 November 1721 and was later described by one local as 'a hideous brick monstrosity' and by another 'totally out of keeping with the old sandstone tower'. Following the last service on 30 March 1873 it was demolished and the furnishings auctioned.

St Giles' was once more reconstructed when Sir George Gilbert Scott began work on a new chancel and nave compatible with the tower using Blythe Marsh stone at a cost of £17,153. The foundation stone was laid by Miss Coghill on 16 September 1873, in the presence of the Bishop of Lichfield. As it was unsafe to ring the bells in an unsupported tower, hand bells welcomed the beginning of work. It was consecrated on Ascension Day 26 May 1876. During the time of rebuilding services were held in a temporary corrugated-iron church in the Ironmarket, which was later sold to Boothen parish, Stoke, in 1877.

All this work uncovered the remains of four medieval chantry chapels and according to records, the earliest was established in 1318 by William Swanlid, a town merchant, to honour St Katherine. In 1510 Newcastle Butcher's Guild commissioned a banner and kept a large candle – costing £10 – alight before a statue of the Virgin Mary in memory of their deceased members. Chantries were banned by King Edward VI in 1548, so prohibiting prayers for the dead.

Before the predecessor to the present Guild Hall was built St Giles' apparently hosted the townsmen's meetings and the Borough Court where the common land was allotted.

Inside, the chancel arch is 40 feet high and 24 feet wide. The nave has two rows of six Gothic arches. The front pew on the right is the Mayor's seat for civic occasions, and this and where the mace stands have replaced the recovered seventeenth-century wrought-iron canopy which is now in the Victoria and Albert Museum, London. The previously auctioned eighteenth-century communion table was rescued from a cottage in Lower Street.

Two items are all that remain today from the medieval church: a recumbent stone male figure with crossed arms, a sword in the left hand and a glove in the right, discovered under the floor in 1848 lying at the south end of the nave; and the oak pelican which originally hung from the roof above the altar, later mounted to become a lectern when the present church was built. Outside is a Saxon stone some 6 feet long and 3 feet wide with interesting carvings. It has been described as follows: 'An incised line divides the stone into two equal parts. On each side has been cut a pediment in the base a long straight central line leading up to and terminating at a perfect circle near the top, the symbol of eternal life.' It possibly came from the site of nearby Blackfriars Priory.

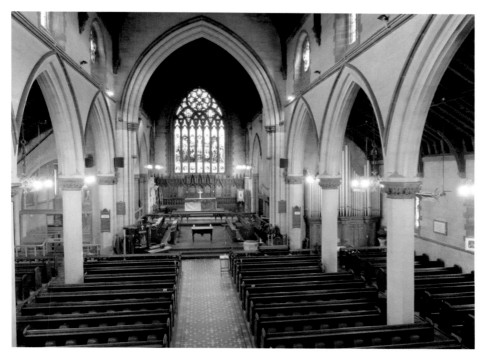

Inside St Giles' with its 40-foot-high chancel arch. (Author's collection)

30. NEWCASTLE-UNDER-LYME, HOLY TRINITY CATHOLIC CHURCH

Positioned on the west side of the former castle pool, St Mary's Chapel was thought to have been constructed shortly after the castle for the benefit of the garrison as the gift of Edmund, Earl of Lancaster. It was first recorded in 1297 and while the exact site is unclear, it is known to have existed in 1544 but was lost by 1608 when it was noted as the previous 'St Mary's Church Beyond the Water'.

Holy Trinity Church had its beginnings in the 1791 Relief Act which permitted Catholics to worship publicly in registered buildings. Twelve such chapels and fifteen priests were duly registered in Staffordshire.

French priest Fr Louis Martin de Laistre, an exile from the French Revolution who settled at Ashley, regularly travelled to say Mass at the Shakespeare Hotel in Brunswick Street, as did a priest from Cobridge. Newcastle became a recognised mission in 1831.

Fr James Egan became the first Catholic priest of Newcastle and remarkably set about designing Holy Trinity Church. Acting as architect, he moved to Newcastle from Ashley to oversee the construction in 1833–4. The church façade is a unique construction of local vitrified common dark blue bricks along with tiers of black arcading to form a wide-ranging collection of parapets and turrets. Fr Egan even designed the moulds for the bricks, which were all the gift of a local brickmaker. The central doorway sits under a window arch with cast-iron tracery. On completion it was described as 'The finest modern specimen of ornamental brickwork in the Kingdom.'

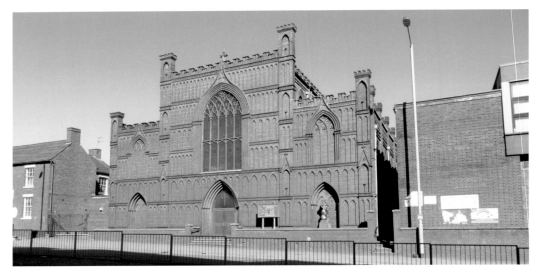

Holy Trinity Catholic Church, Newcastle, with its unique façade constructed of dark blue Staffordshire bricks. (Author's collection)

Originally the south aisle was the presbytery and the north aisle a school before being absorbed into the church in 1864. In 1886 the sacristy was added and the church restored with the current presbytery, built to the east side in the late twentieth century. Outside in the rear car park stands an external bell frame and bell both made by Matthew O'Byrne of Dublin in 1915.

Holy Trinity was one of the first Catholic churches to be built following the Catholic Emancipation Act of 1829.

31. NEWCASTLE-UNDER-LYME, UNITARIAN MEETING HOUSE
Newcastle's Grade II listed Unitarian Meeting House is the oldest nonconformist building in the town and the only active Meeting House in the county.

Dating back to *c.* 1685, the first building was constructed by George Long on land known as the Fullatt below St Giles' Church and registered as an Independent or Presbyterian chapel Meeting House in 1694. The term Unitarian was not generally used before the late eighteenth century and it was the only type of dissenting worship until the 1760s and the advent of Methodism.

In 1705 Revd Edward Orme, the former headmaster of Newcastle's borough school, died leaving a large percentage of his estate to found a school for the education of poor children and as two of his executors were members of the Meeting House, it appeared logical for the school to be established within the building. However, ten years later in mid-July 1715, a mob began to gather in the town two weeks before the Riot Act became law on 1 August – it would be the last opportunity for those opposed to dissenters. Late in the evening the by now drunken rioters attacked the chapel, making a bonfire of the seats, pulpit and gallery spars before setting fire to the building. As compensation for the fire Stafford Assizes awarded a sum of £412 on 23–26 August 1715.

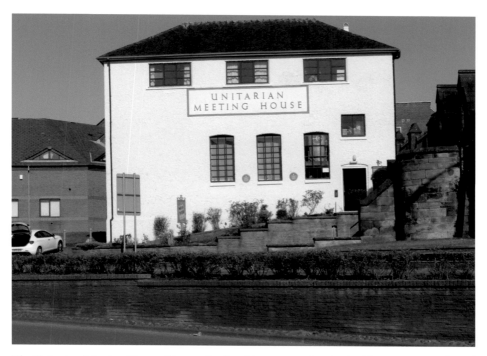

The Unitarian Meeting House, Newcastle, the oldest nonconformist building in Newcastle and the only active one in the county. (Author's collection)

As for the school, the trustees had a new building constructed – the first Orme school – adjacent to the Meeting House and built in part with material salvaged after the fire. The school closed in 1825.

Today's Meeting House was built in 1717 with the top floor added in 1926 to accommodate an expanding Sunday school. For many years it lay hidden behind heavily populated terraced houses and could only be accessed via an unassailable set of steps from St Giles' churchyard until the town's bypass was constructed in the 1960s leaving it now sitting alongside a busy dual carriageway.

Perhaps less well known is that the Wedgwood family had a long association with the Meeting House. Katherine, sister of Josiah, married Revd William Willett, a minister there from 1727 to 1776. Charles Darwin also attended, as did Joseph Priestley, who led the worship there *c*. 1761. It was the chapel's heyday with a congregation numbering over 300.

Inside, a first-floor balcony room with an organ which originally came from a chapel in Knutsford overlooks the chapel. The stained-glass window came from Whitchurch in the 1920s and the pews from the former Brunswick Street Wesleyan Chapel in 1957. More recently both the pews and carpet have been removed to disclose the original wooden floor.

Newcastle's Meeting House is a rarity as its early eighteenth-century main chapel area still has its original layout.

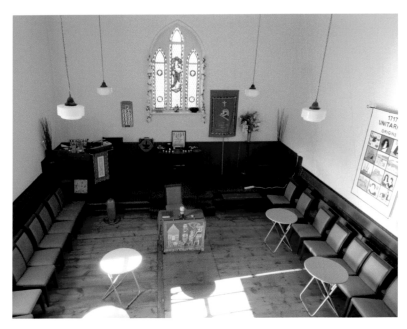

The main
chapel with its
original early
eighteenth-century
layout. (Author's
collection)

32. NORTON IN THE MOORS, ST BARTHOLOMEW'S ANGLICAN CHURCH

St Bartholomew's Church was built in 1737 by Richard Trubshaw on the site of a Saxon chapel and lies on the edge of the Staffordshire Moorlands. It is one of Stoke-on-Trent's oldest buildings.

The tower and western end of the church date from 1737, and the church doubled in size when the eastern half was rebuilt and extended by architect J. H. Beckit of Longton and builders Charles Cope of Tunstall. Constructed of stone and brick, the new foundation stone was laid by Colonel Hesketh on Thursday 22 May 1913. The nave roof was repaired and the six bells quarter-turned and rehung – this enabled the clappers to strike a different part of the bell, thus preventing excess wear on the bell's surface. This cost a total of £2,700. Today, there are eight bells with a 12cwt tenor.

Interestingly, due to its then remote moorland location Norton church was known as Staffordshire's Gretna Green. Because marriages had to be conducted by members of any clergy, there became several so-called 'lawless churches' which managed to claim exemption from ecclesiastical jurisdiction and where clergy performed irregular but legal marriages – usually where the clergyman held the 'living' of a parish and so were less likely to risk disapproval from the relevant authorities. St Bartholomew's parish claimed exemption from the formality of banns and the requirement to produce a licence and so became the destination for many an anxious couple, confirmed by the considerably high number of marriages recorded there.

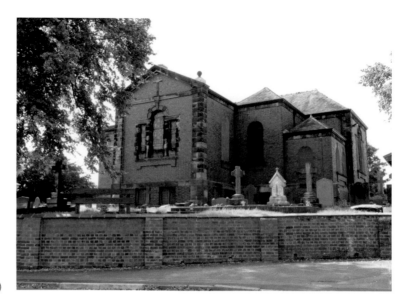

St Bartholomew's
Church, Norton-
in-the-Moors,
which was at one
time Staffordshire's
'Gretna Green'.
(Author's collection)

33. ROLLESTON ON DOVE, ST MARY'S ANGLICAN CHURCH

The present church of St Mary mostly dates from 1216 to 1272, although the Romanesque-style north entrance is *c.* 1130 and there are records telling of a previous church on the site in AD 900–1000.

Constructed of ashlar sandstone, it unusually has the main entrance on the north side while the south doorway gave private access for the local landowning Mosley family.

In 1884 the gallery was taken down and the walls stripped of whitewash. New pews, made from the oak of former seating, were installed. In 1892 architect Sir Arthur Bloomfield carried out further renovations with the addition of the north aisle and the external vestry demolished to extend the south aisle. Inside, a single bay to the north has an unusual seventeenth-century window with three trefoil-topped lights whereas the south aisle windows are of medieval stained glass and those more recent ones in the chancel are by Charles Eamer Kempe. The south aisle also benefits from a hagioscope through which parishioners can observe the elevated Host at the consecration.

The oldest monument is to John Rolleston (d. 1485) and his wife, Margaret. Another is of Robert Sherbourne, born at Rollaston *c.* 1453, who was Bishop of Chichester from 18 September 1508 until his compelled resignation in June 1536. He died soon afterwards on 21 August 1536. To the left of the High Altar is the sixteenth-century alabaster Cauldwell monument to Thomas, his wife and three sons, and towards the east end of the south aisle lies the alabaster tomb of Sir Edward Mosley (1569–1638) who purchased the estate from the Rolleston family.

The thirteenth-century tower has an 11cwt ring of eight bells, one of which is dated 1586.

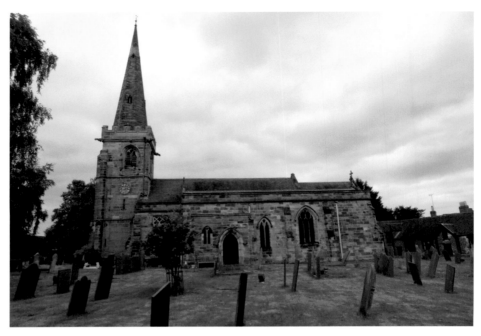

St Mary's Church, Rolleston-on Dove. (Author's collection)

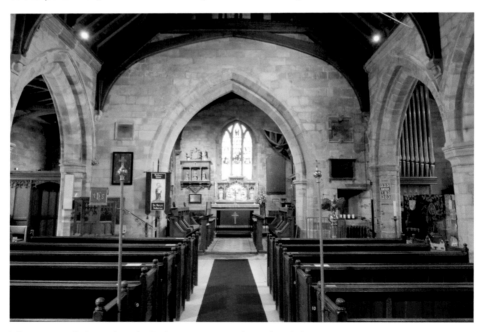

The nave and chancel with the hagioscope to the right of the chancel and where the pews are constructed from the recycled oak of earlier seats. The sixteenth-century alabaster Cauldwell family monument is to the left of the altar. (Author's collection)

The Saxon
cross, relocated
from Tatenhill
church via
Rolleston Hall
by Oswald
Mosley.
(Author's
collection)

In 1910 Sir Oswald Mosley, 5th Baronet and father of his political namesake, upset the villagers by proposing that the entire south aisle be for the exclusive use of the Mosley family. Angry parishioners protested by taking away the hassocks and leaving bent pins on the Baronet's pew. It was all in vain though as the Consistory Court granted Sir Oswald thirty-eight seats.

Outside at the base of the tower stands a Saxon cross, thought to be ninth century, with Danish early Viking influence. It was placed there by Oswald Mosley in June 1897. Originally from Tatenhill church, it was part of the porch floor there before being taken to Rolleston Hall and on to its present location. Sir Oswald's grave is in the churchyard.

34. STAFFORD, ST MARY'S ANGLICAN CHURCH

In *c.* AD 700 St Bertelin, the founder and patron saint of Stafford, constructed a wooden chapel which was rebuilt in stone *c.* AD 1000, the foundations of which are beside the west tower of the current church. Here in 1954 archaeologists discovered not only the wooden remains of the church but also fragments of a timber preaching cross 5 feet below the surface, thought to be where St Bertelin began his mission.

In St Mary's nave there is some Norman stonework, which suggests that a larger church was joined to St Bertelin's Chapel soon after the 1066 Conquest. It was replaced by the present church in the late twelfth and early thirteenth centuries, which also connected to the original chapel through a doorway in the west wall until 1801 when the old chapel was demolished to accommodate the need for more burials in the churchyard. The transepts were added in the fourteenth century and the clerestory in the fifteenth century. The central octagonal tower, 33 feet square at the base, is one of only a few examples in the country. A spire

 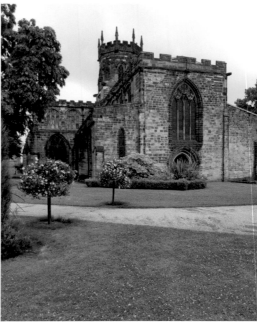

Above left: The adjacent site of St Bertelin's Anglo-Saxon church, the founder and patron saint of Stafford. (Author's collection)

Above right: The parish church of St Mary, Stafford, with its octagonal tower. (Author's collection)

once sat above the tower until a storm of 1593 caused it to fall onto the south transept which, along with the tower, was repaired. The spire, however, was not rebuilt.

The church was recorded in the Domesday Book as being a Collegiate with a Dean, thirteen Prebendary Canons and four Vicars choral. Then in the thirteenth century it became a Royal Peculiar free from the Bishop's jurisdiction. This understandably conflicted with the then new Bishop of Lichfield Roger de Meyland, who in December 1258, accompanied by armed troops, forced entry into the church. A pitched battle was fought inside, resulting in some of the Canons being wounded. St Mary's continued as a Collegiate until the Dissolution of Colleges and Chantries Act of 1548 when it became one of 3,000 to be dissolved throughout the country.

Stafford was taken by the Cromwellian army in the Civil War of 1642–51, who misused the church as a barracks and stables. So much damage was inflicted that by 1777 it had to be closed. By then the chancel was only used for a monthly communion service and private box pews occupied the nave, while galleries bordered three sides overlooking the pulpit to the front of the west gallery. St Mary's was completely restored by Sir George Gilbert Scott between 1841 and 1844. Augustus Pugin described it as the 'best restoration in modern times'.

Inside, the oldest item is the font in the west end of the nave. It once stood in nearby St Chad's Church and is of a Byzantine style virtually unknown in Britain, said to have been bought from Palestine by Moorish craftsmen. It has four semi-circular conjoined bowls and carved with grotesque figures, and the inscription reads:

Font Discretus non es is non fugis ecce leones
(you are not wise if you do not flee the lions)
Tu de Jerusalem ror-alem me faciens talem tam
(Thou bearest from Jerusalem (the water of life) endowing me with beauty and grace)

In the tower plans were made to replace the 19cwt ring of ten bells as some of them were 'odd struck' (the bell is struck by the clapper too early or too late) and the mid-nineteenth-century wooden bell frame had begun to move, making life more demanding for the ringers. There were plans to replace the ring with the 18cwt ring of ten bells from the redundant St John's Church, Hanley. A new steel bell frame was commissioned and two new bells cast to make a ring of twelve with a viewing platform above to observe the bells safely and a ringing museum created in the old clock toom. As some of the old bells are of historic interest, five of them are to be kept as clock bells and the old fifth bell hung separately as a

The Byzantine-style font by Moorish craftsmen which is said to have originated in Palestine. (Author's collection)

training bell; the others are to be sold. The bells were removed from Hanley in the summer of 2019, the project costing some £180,000.

35. STAFFORD, ST CHAD'S ANGLICAN CHURCH

St Chad's Church is the oldest building in Stafford dating from the twelfth century. A Latin inscription on the impost at the north-east tower crossing reads: ORM VOCAT. UR QUI ME CONDIDT (He who built me is called Orm), otherwise known as Orm le Guiden, Lord of Knypersley and returning Crusader.

Before 1874 the church was obscured behind a row of shops and approached via an archway off Greengate Street.

The church was never a rich one and at one time it was granted to a prebendary of Lichfield Cathedral. Following the rebuilding of the tower in the fourteenth century, St Chad's suffered many years of neglect, beginning in the seventeenth century with the destruction of the original aisles, removal of the transepts and the arcades bricked up. In the 1740s it became so unstable that the west end of

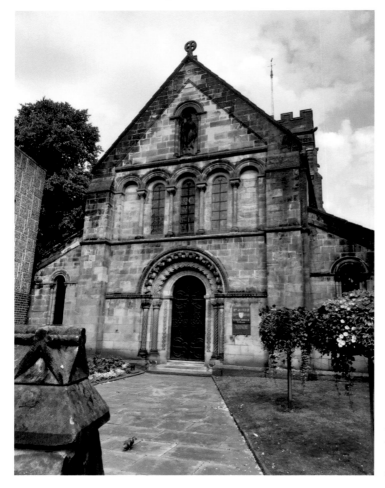

St Chad's twelfth-century church, the oldest building in Stafford. (Author's collection)

the nave collapsed. A new west front was constructed in brick with iron-framed windows by Richard Trubshaw, who also rebuilt the tower parapets and plastered the interior walls to cover any Norman architecture. Four of the church's bells were sold to meet the cost.

In the 1850s Henry Ward of Stafford undertook some restoration of the chancel and later in the 1870s George Gilbert Scott rebuilt the west front, using stone, in the Romanesque style, constructed a new aisle on the south side and reopened the south arcade. Following his death in March 1878 Robert Griffiths, architect and county surveyor of Staffordshire, continued the work using Scott's plans. Between 1880 and 1886 a new north aisle was added, the north transept restored and the same arcade reopened. The tower was also repaired. The south transept was built in the 1950s.

Outside, the archway above the entrance is a Norman copy carved with a zig-zag pattern and sixteen grotesque heads in keeping with the original Norman architecture inside of the nave, clerestory and arcade and where the columns supporting the chancel arch have a combination of forty-eight individually carved heads – no two alike – positioned sideways and vertically upon them.

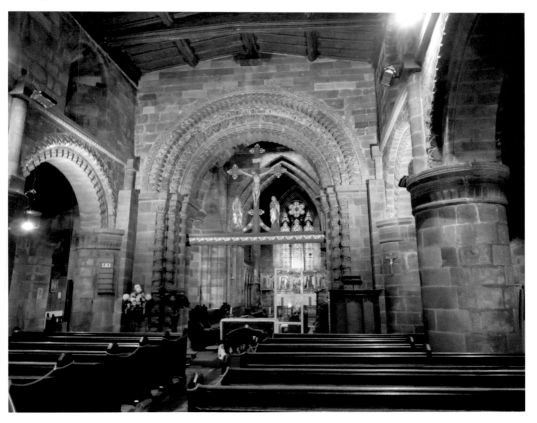

St Chad's Norman interior with original carved columns. (Author's collection)

36. STAFFORD, ST AUSTIN'S CATHOLIC CHURCH

In 1344 Ralph, Barron Stafford founded an Austin friary in the town, and at the Dissolution this was sold to the Stanfords of Rowley Hall.

Much later, Mary, Comtesse de Rohan-Chabot, the eldest daughter of William Stafford-Howard, established a fund in 1766 to support a priest, the first of whom was Fr Thomas Barnaby (d. 1783) who was said to have celebrated Mass in the garret above a house on the Green. Then his successor, Fr John Corne, rented a house in Tipping Street where he built a chapel in the garden. This was superseded in 1788 when the Berringtons leased a half-acre of land on a plot known as Middle Friars where Fr Corne built a priest's house with a small chapel – 34 feet long by 18 feet wide – concealed behind it and dedicated to St Austine (St Augustine of Hippo) which opened on 31 July 1791. By 1817 the chapel was too small, so Edward Jenningham of Stafford Castle, having bought the site for £100, financed the construction of a larger church in 1817–9 which incorporated part of the former chapel. It was inaugurated on 29 October 1822. This too was to prove inadequate as by 1857 the church was 'Crammed morning and evening' and so the money was raised to construct an even larger church.

The present St Austin's was designed by E. W. Pugin to a lesser scheme than his original ambitious plans at a cost of over £3,000, £300 of which was spent on the stained-glass windows and a further £250 on the furnishings. Whilst the foundation stone was laid on 21 May 1861 the church opened on 16 July 1862, with Bishop William Bernard Ullathorpe in attendance. It was consecrated on 26 July 1911 by Bishop Edward Isley of Birmingham.

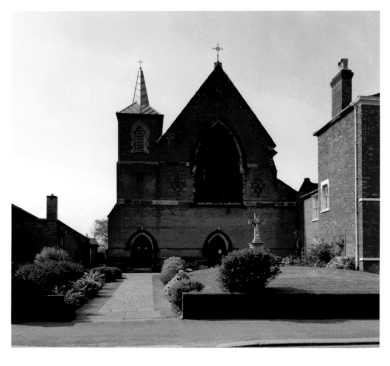

St Austin's Catholic Church, Stafford, built on the site of the medieval Austin friars priory. (Author's collection)

In 1884 Peter Paul Pugin added a new High Altar and stone reredos, later removed in 1958, together with altars in the Lady Chapel (1884) and the Sacred Heart Chapel (1894). The current sacristies were added in 1900 and to mark the centenary in 1962 the present tower and low steeple replaced an earlier bell turret housing a single bell, the gift of the Masfern family.

The church underwent substantial restoration beginning in 1995 and by 1998 much of the earlier work had been undone, revealing many original features. This included the removal of the 1973 false ceiling above the nave and the 1958 canopy above the altar along with a complete redecoration of the interior.

St Austin's is Stafford's Catholic Mother Church and stands on land that was once part of the medieval Austin friary.

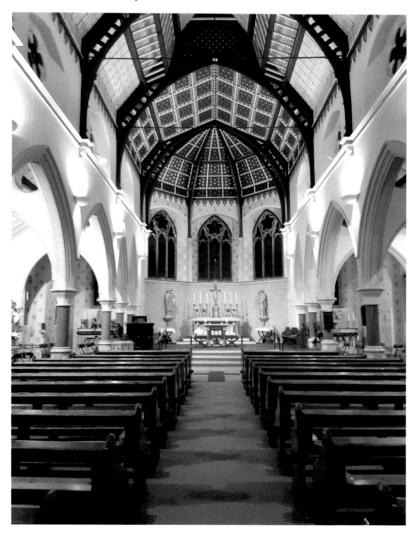

The interior with Peter Paul Pugin's High Altar and reredos. (Author's collection)

37. STOKE-ON-TRENT, ST PETER AD VINCULA ANGLICAN CHURCH

A wooden church dating from around AD 670 stood close to a ford across the River Trent, which in 805 was replaced by a stone building surrounded by a moat.

Stoke old church had a Saxon nave, a fourteenth-century (either new or rebuilt) chancel and tower above a pointed roof, replaced by a flat one of lead around the sixteenth century. By 1820 the church was deemed too small and liable to flooding, so work began on the present church of St Peter in 1826 on Glebe land adjoining the old churchyard which was purposely raised above river level. The corner stones were laid on 26 June 1826 with the Rector Dr John Chappel Woodhouse placing one at the north-east corner; another at the south-west corner was set by Josiah Spode.

Constructed in the Early English style and designed by James Trubshaw and Thomas Johnson with a 112-foot tower, it was completed in 1829 at a cost of over £14,000 and consecrated on 6 October 1830. At the time it had the biggest unsupported ceiling in the Midlands.

Within two months of the new church opening the old one was razed and some gargoyles were later discovered incorporated into a row of terraced houses close by in Brook Street. Many of the monuments were transferred to the new church. Interestingly, during the demolition a corbel head of stone was found embedded in a wall with the Latin inscription 'DCCC1' (801).

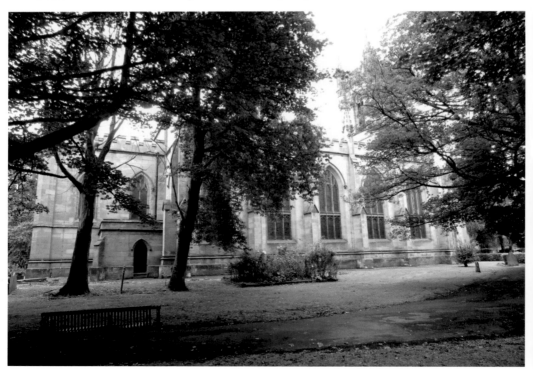

St Peter ad Vincula Minster, Stoke, built in 1826–29 in the Early English style. (Author's collection)

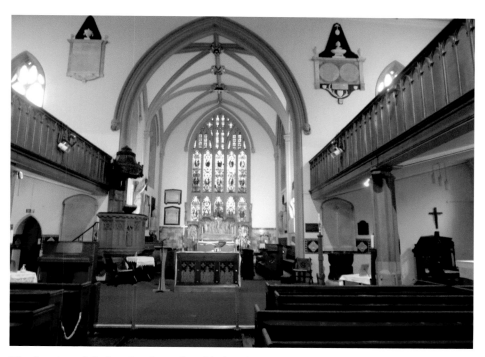

The Interior of St Peter's where the old church's altar stone forms part of the High Altar. (Author's collection)

Inside, galleries of oak wainscot surround three sides while the reredos is of English alabaster and the High Altar stone is original from the medieval church. It was found on the site of the old church and taken in the late 1920s to the now called Peace Chapel in the south gallery. The weight, though, became too heavy for the supporting beams and the stone was re-cut and re-consecrated in 1933 as the new altar. The clergy and choir stalls were the gift of an anonymous benefactor in 1897 and cost 200 guineas (£210). Perhaps the most interesting item is the Anglo-Saxon font dating from the first stone-built church. When the old church was demolished, it was sold to Mr John Tomlinson of Hartshill who for many years used it as a giant plant pot in his garden. It was returned in 1876, restored in 1932 and positioned in the present church. Also, in the old church hung a ring of six bells cast in 1705. A completely new ring of eight bells was commissioned for the new church, dedicated in May 1832. Following two re-hangings it was decided in 1969 to re-cast them into a lighter 17cwt ring of ten bells to be hung 30 feet lower in the tower, so preserving the building's fabric.

Outside, the churchyard has a Saxon cross dating from 750–80 which bears the earliest known example of the Staffordshire knot. There are also two stones memorials, to Sibil and Henry Clarke (d. 1684) who were both 112 years old, along with the grave of Josiah Spode (1733–97). Close by is the site of old St Peter's High Altar and two remaining stone arches through which can be seen

The original Saxon font placed in the present church in 1932. (Author's collection)

the grave of Josiah Wedgwood (1730–95). As a dissenter he was originally buried in the old church porch but now his tomb lies without.

In 2005 St Peter ad Vincula (in chains) became the Minster Church for the City of Stoke-on-Trent.

38. STONE, THE IMMACULATE CONCEPTION AND ST DOMINIC'S CATHOLIC CHURCH

St Dominic's is unusual as it is one of the few churches founded by a woman, Mother Margaret Hallahan. Earlier, in 1842 Blessed Dominic Barberi visited the Crown Hotel to say Mass in a room there before moving to a Mass centre at Elmhurst, the home of James Beech in modern-day Margaret Street. Beech was to give an acre and a half of land for a Catholic chapel in Newcastle Street, the first one to be built in Stone post-Reformation.

Plans for the chapel, costing £1,000, were offered by A. W. N. Pugin; however, a less elaborate school chapel was eventually decided upon for £500 – mainly financed by Mr Beech. The foundation stone was laid in July 1843 by Dominic Barberi and the church was opened on 22 April 1844 and dedicated to St Anne. The school opened the following day, at a total cost of £600. Fr Dominic wrote 'My hope is that the little building at Stone will be the grain of mustard seed which blessed by God will become a great tree.'

Later Mr Beech, encouraged by his son, donated a further plot of land, this time to Mother Margaret Hallahan (1802–68) and in 1851 she purchased some

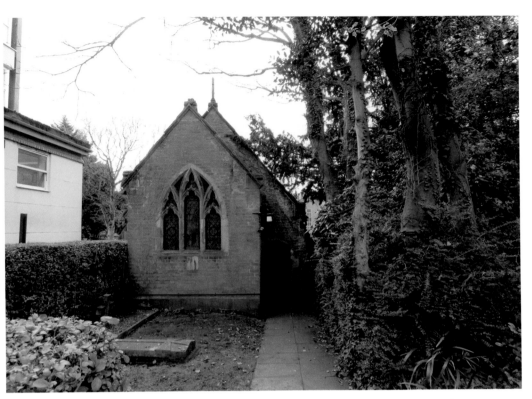

St Anne's Chapel, built by A. W. N. Pugin, which is now in the convent grounds. (Author's collection)

adjacent cottages and a field on which to build a convent with four square cloisters and a bigger public chapel – St Dominic's. Mother Margaret was the founder of the Dominican Congregation of St Catherine of Siena (Third Order) and Stone convent became the Mother House.

Constructed in the Gothic style by Charles and James Hanson in 1852–4, the foundation stone was laid by Bishop Ullahorpe on 4 August 1853 and on 3 May the following year John Henry Newman preached when three altars were consecrated by the Bishop. St Dominic's was finished in 1861–3 by Gilbert Blount who completed the east end; it was consecrated on 4 February 1863. Inside, Mother Margaret is buried in the Nuns' Choir 'Beneath the feet of her sisters' and Bishop Ullathorpe lies nearby in the sanctuary. The northern gable has a connecting door to the convent.

St Dominic's Church was presented to the Archdiocese of Birmingham by the convent in 1968. Around this time the original rood screen together with those in the side chapels and Nuns' Choir were removed and much of the décor painted over. In 2002 a narthex was built at the eest end of the nave.

St Anne's Chapel was incorporated into the convent grounds where it served as a school on weekdays before a new building was constructed in 1870.

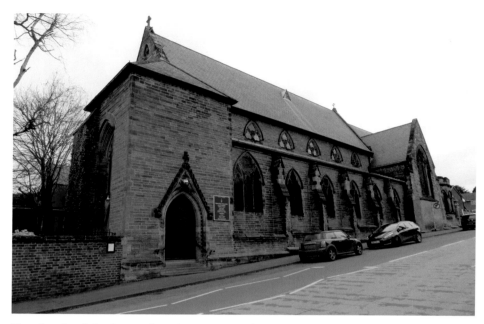

The church of the Immaculate Conception and St Dominic founded by Mother Margaret Hallahan and designed by Charles and James Hansom. (Author's collection)

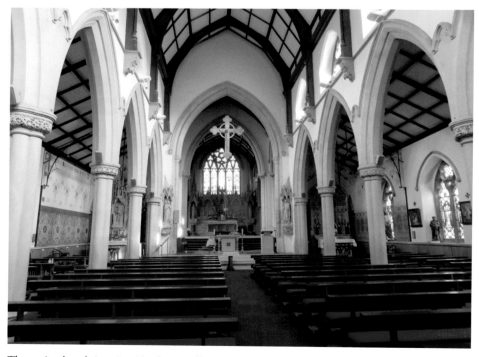

The main church interior. (Author's collection)

39. SWYNNERTON, ST MARY'S ANGLICAN CHURCH; OUR LADY OF THE ASSUMPTION CATHOLIC CHURCH

Both St Mary's Anglican and the Catholic church of Our Lady of the Assumption sit close together either side of the driveway to Swynnerton Hall, home of the Fitzherbert family.

The much older Anglican church dates from the twelfth century with thirteenth-century aisles and chancel, a fourteenth-century south chapel and a fifteenth-century tower housing a 7cwt ring of six bells. During the nineteenth-century restoration when the clerestory was added an 8-foot-high late thirteenth-century seated stone-carved image of Christ the King was discovered buried under the floor a few feet from where it is today in the former Lady Chapel, now the vestry. It is said to have been bought from Lichfield Cathedral to Swynnerton at the time of the Commonwealth and hidden for safe-keeping, perhaps wisely as Cromwell's soldiers advanced through the village destroying the manor house.

The house was restored in the early 1660s but in 1725 Squire Thomas Fitzherbert built a new one –Swynnerton Hall – designed by Francis Smith of Warwick, on a different site where he soon realised that the village interrupted his view. He moved it roughly a mile away by enclosing the common, buying out freeholders and rehousing tenants, leaving only St Mary's Church on the estate.

From 1782 to 1787 the Fitzherbert family were served by two Benedictine priests before the 1791 Catholic Relief Act when the hall chapel, administered by Fr John Howell, was registered for worship. By 1848 it had become so unstable

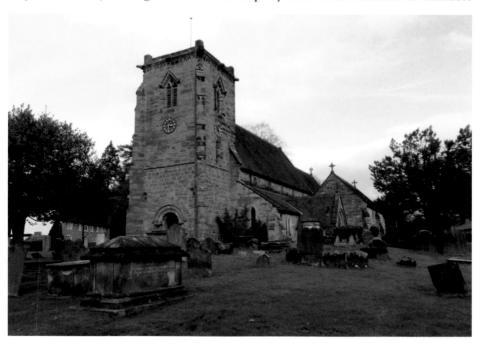

The twelfth-century St Mary the Virgin Anglican Church, Swynnerton. (Author's collection)

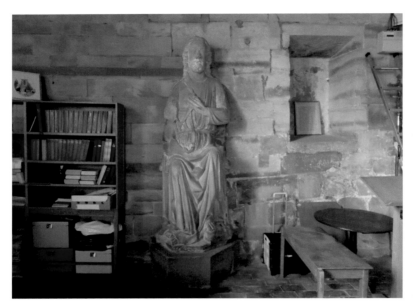

The 8-foot-high thirteenth-century statue of Christ the King discovered buried under the floor, believed to be for safe-keeping during the Commonwealth. (Author's collection)

that it was 'buttressed by a large triangular prop' and the gable above the chancel arch was considered dangerous to the congregation. So, a new chapel standing to the west of Swynnerton Hall was commissioned by Maria Teresa Nee Gandolfi, the widow of Frances Fitzherbert, and her son Basil Fitzherbert.

Our Lady of the Assumption was designed in Victorian Gothic style by Gilbert Blount and built in 1868–9 of local stone by George H. Gough, at a cost of £8,000 – the foundation stone was laid by Bishop William Ullathorpe in 1868.

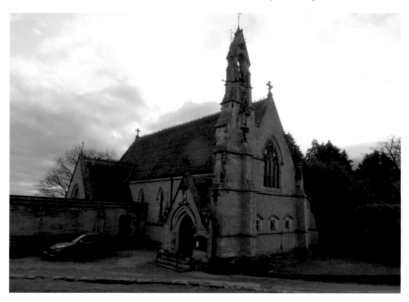

Our Lady of the Assumption Catholic Church, Swynnerton, commissioned by Basil Fitzherbert and his widowed mother, Maria Teresa Fitzherbert. (Author's collection)

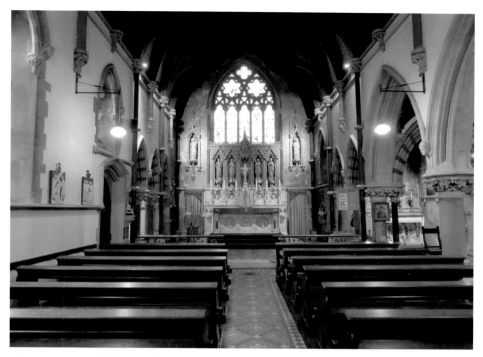

The sanctuary with the carved statues on the reredos. (Author's collection)

Inside, the reredos has carved statues of Our Lady, St Joseph, St Theresa, St Basil and two more saints. The window to the right of the sanctuary was donated by Basil Fitzherbert and is dedicated to the charity of his mother, Emily.

40. TAMWORTH, ST EDITHA'S ANGLICAN CHURCH

In the eighth-century Kingdom of Mercia, Tamworth was a significant settlement. It was thought that here King Offa celebrated the major Christian festivals and St Chad had built a wooden church in the seventh century. Then, in 874, the town and church were destroyed by the Danes, leaving Ethelfleda, Queen of Mercia and daughter of Alfred the Great, to rebuild the church. The Danes sacked Tamworth once more in 943 and the church was reconstructed again, this time by King Edgar who refounded it as St Editha's in 963. Possibly, Editha was King Edgar's aunt who died *c.* 960 and was canonised soon after. Disaster struck again on 23 May 1345 when a fire spread through the town and razed the church. The one we see today, with a west tower, was rebuilt and enlarged over the following twenty years by Dean Baldwin de Witney who died in 1369 and was buried within.

St Editha's was a collegiate – in the twelfth century it had a dean and six prebendaries – until 1548 when the college was dissolved following the 1547 Dissolution of Colleges Act and converted to a parish church.

Externally, it was restored by Benjamin Ferrey and George Gilbert Scott in the 1850s and again by William Butterfield *c.* 1871. Inside, the first two chancel arches

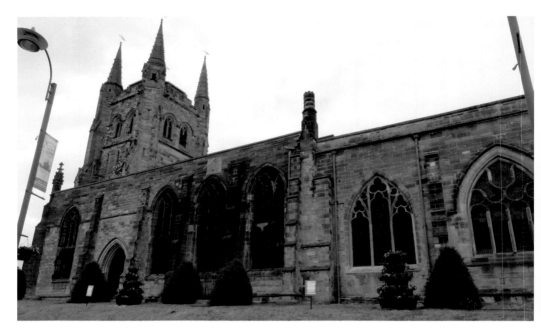

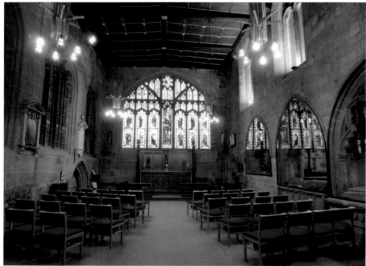

Above: St Editha's Parish Church, Tamworth, the largest medieval parish church in the county and famous for its double-helix staircase in the south-west corner of the tower. (Author's collection)

Left: St George's Chapel, which stands on the site of an earlier chantry chapel. (Author's collection)

are Norman and to the south of the chancel is a deeply splayed round-headed window sitting in what would have been a twelfth-century outside wall. The fourteenth/fifteenth-century St George's Chapel occupies the site of an earlier chantry chapel.

While St Editha's is the largest medieval parish church in the county with a 21cwt ring of ten bells, it is more famous for the rare double-helix staircase in the south-west corner of the west tower, built in 1380–1420. Independent of each other, one entrance is on the outside and the second inside the church, meaning

An illustration of the rare double-helix staircase. (Author's collection)

that two people can climb the stairs simultaneously unaware of the other until they reach the top. One assent has 101 steps and the other 106, designed so that the floor of one is the roof of the other.

Only two other double-spiral staircases exist – at All Saints, Pontefract, and the other at Chateau de Chambord, France.

41. TRENTHAM, ST MARY AND ALL SAINTS ANGLICAN CHURCH

During the seventh century, King Ethelred of Mercia endowed a Benedictine nunnery on the site of the present church by the River Trent at the behest of St Werburgh, daughter of King Wulfhere and one-time Abbess of Trentham. She died at Trentham on 3 February 700.

Sometime later, the Domesday Book records the estate as a Royal Manor with one priest. Then in 1100 it was granted to Ranulf de Gernon, 4th Earl of Chester, who subsequently founded an Augustinian priory *c.* 1150 dedicated to St Mary and All Saints, the pillars of which are incorporated into the present church. In the fourteenth century the canons at Trentham were often obliged to provide free food and accommodation to former soldiers and royal servants.

The priory was suppressed in 1538 at the Reformation and a year later granted by King Henry VIII to his brother-in-law George Brandon, Duke of Suffolk. In 1540 the estate was sold to James Leveson who transformed the priory buildings into a private house which was rebuilt in 1634 in the Elizabethan style. While many large houses had a chapel, Trentham Hall was unique in having a parish church within its boundaries. St Mary's went on to suffer desecration in the Civil

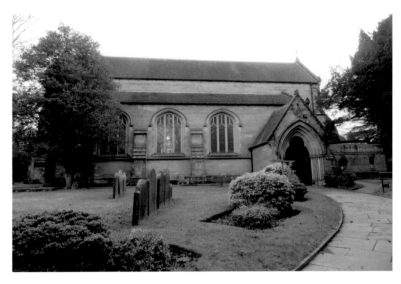

St Mary and All
Saints Parish
Church, Trentham,
built on the site of
the Augustinian
priory endowed
by the Earl of
Chester. (Author's
collection)

War when Commonwealth soldiers used it as a stable for their horses and fired shots at King Charles I's royal coat of arms, still visible today above the north door. It was repaired in 1633; the rood screen and altar date from this time.

While a new separate hall was constructed *c.* 1730, the church remained unchanged until George Granville Leveson Gower, the 2nd Duke of Sutherland, extensively rebuilt the hall and church with plans by architect Charles Barry, which incorporated the nave pillars on their original site. It was finished in 1844. Inside, St Mary's has memorials to the Sutherland family and traditional Minton tiles. In the churchyard is a penitential cross considered to be the oldest artifact.

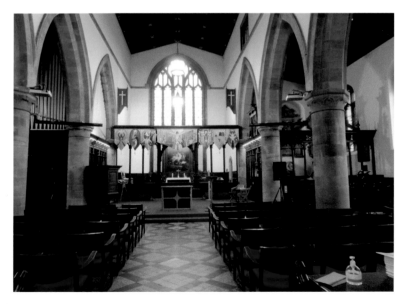

The nave and
chancel of
St Mary's and All
Saints, Trentham.
(Author's
collection)

42. TUTBURY, ST MARY'S ANGLICAN CHURCH

St Mary's Church, Tutbury, was founded by Henry de Ferrers on or close to the site of a Saxon church below the castle walls. Building began *c.* 1086 and the church was consecrated on 15 August 1089 – The Assumption of the Virgin Mary. There is some dispute as to whether the then adjoining priory was founded at the same time or some sixty years later by Robert de Ferrers.

The Benedictine priory was built in memory of the Ferrers family and William the Conqueror and his wife Matilda to enforce the Norman influence in the region, with a prior and twelve brothers coming from Saint-Pierre-Sur-Dives in Normandy.

Originally the church was around twice as long, cruciform in shape with a central tower over the crossing, two transepts and two turrets at the west end. The priory buildings occupied some 3 acres to the north side. During a rebellion by Robert de Ferrers in 1266 the south aisle was damaged, resulting in its east end being rebuilt by Edmund, Earl of Leicester in 1307. Later, during the wars with France Tutbury, with a Mother house in Normandy, had to prove that they were a conventional priory to escape closure in 1402. The last French prior died in 1433.

They could not survive the Reformation though and surrendered to the Crown on 14 September 1538 when the priory was dissolved and the land given to Sir William Cavendish. The priory buildings were then demolished along with the church's central tower, the transepts and two bays of the nave. The eastern

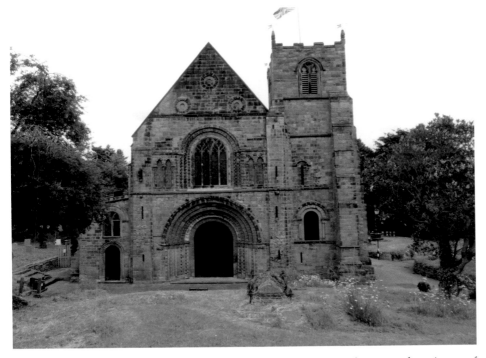

St Mary's Parish Church, Tutbury, once part of the Norman priory whose west front is one of the county's best examples of Norman architecture. (Author's collection)

end was walled off and the clerestory removed to lower the roof. The present tower – with a 10cwt ring of eight bells, four of which date from 1699 – was possibly constructed in the sixteenth century under Queen Elizabeth I. The last prior became the first vicar of the new parish church.

Today, St Mary's west front is one of the finest examples of Norman architecture, with a door 14 feet high and 9 feet 6 inches wide under six carved arches, the second of which above the door is the earliest example of alabaster carving *c.* 1160 and is unique in that it's the only exterior alabaster arch in the country. The south doorway arches too are Norman, *c.* 1150; however, the lintel – carved with a bear hunt scene – within the twentieth-century tympanum is reputed to be Saxon and was probably reused from the original church. For many years it had been a window until restoration as a doorway in 1913. In 1820–2 a new north aisle was constructed by Joseph B. H. Bennett of Tutbury, then in 1866–8 George Edmund Street restored the nave and added a new chancel and apse donated by Sir Oswald Mosley of Rolleston.

Outside, in the churchyard are some of the graves from the memorable underground explosion at nearby Fauld on 27 November 1944 in which sixty-eight people died. So great was the blast that it caused a pane of glass to crack in Checkley church over 13 miles away.

St Mary's Church is the oldest functioning building in the county.

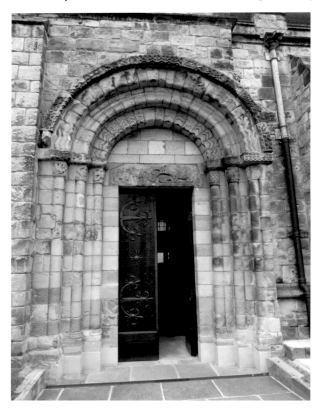

The Norman south doorway where the lintel is reputed to be Saxon. (Author's collection)

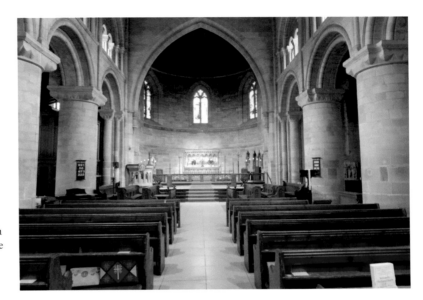

The interior of St Mary's, which was the one-time priory church nave. (Author's collection)

43. UTTOXETER, ST MARY'S CATHOLIC CHURCH

Around 1832 Fr J Dunne of Cresswell began the Uttoxeter mission, travelling there to say Mass in the stable of the Blue Bell Inn. He was succeeded by Fr George Morgan, who initiated the building of St Mary's and it is said that he sold his paternal estate to help finance it together with John Talbot, the 16th Earl of Shrewsbury who engaged A. W. N. Pugin as the architect. Work began on 4 October 1838 to build the first post-Reformation Gothic church in England and like all future commissions for the Earl, at his request it included features from the ruined Cistercian Croxden Abbey near Uttoxeter. Pugin wrote of St Mary's,

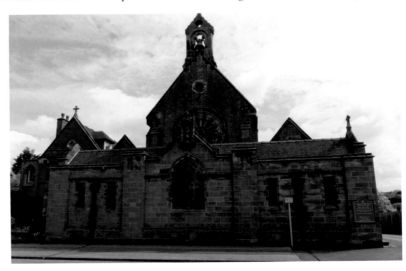

St Mary's Catholic Church, Uttoxeter, the first church to be designed by A. W. N. Pugin. (Author's collection)

The church interior extended in 1879 by Augustus's son Peter Paul Pugin. (Author's collection)

'In strict accordance with the rules of ancient ecclesiastical architecture.' It was constructed by John Denny with craftsmen from the Alton estate and stone carvings by Mr Roddick. The church was opened on 22 August 1839.

By the late 1870s Peter Paul Pugin, Augustus's son, enlarged the church by extending the chancel, adding a north-east Lady Chapel and a choir gallery, all eventually completed in 1879. Further extension works in 1912–3 by Henry Sandy and paid for by Samuel Bamford saw the addition of side aisles, a new narthex and south-east Lady Chapel (the former Lady Chapel became an organ chamber) and the removal of the choir gallery. In 1998–9 the church was reordered with a forward altar and the altar rails removed.

Inside is the original Pugin rose window and in the Lady Chapel above the altar is a mosaic of Mary highlighted in gold.

44. WOLSTANTON, ST MARGARET'S ANGLICAN CHURCH

St Margaret's occupies an ecclesiastical site that can be traced back to the seventh/eighth century. The base of the present tower is of *c.* twelfth-century construction, making it the oldest building in the area.

The original Saxon church was possibly partially destroyed by the Danes in the mid-eleventh century, though the nave and parts of the side aisles probably survived and the building was repaired. Then later, in 1623 the upper parts of the church were reconstructed with the addition of battlements. There was some refurbishment

St Margaret's Parish Church, Wolstanton, who's unusually positioned tower on the north side is a strategic landmark in the area. (Author's collection)

in 1803–4; however, in 1858 St Margaret's chancel was completely rebuilt in the Gothic style by Ralph Sneyd at his entire expense; the architect was Anthony Salvin and the contractor Mr Bryan of Stoke. Meanwhile, it was decided – mainly on the insistence of Edward Wood Esq of Porthill – to rebuild the rest of the church, which had become so dilapidated it was in danger of collapsing. Initially, the plan was to demolish only the outer walls; however, the stone pillars were also found to be weakened, so the decision was made to raze the building. Construction began in January 1859 by architects Ward and Sons of Hanley with building contractors Messrs Robinson and Co. of Hyde, at a cost £4,500, which included the addition of three pinnacles at the base of the steeple and the staircase turret extended to create a spirelet on the fourth corner. The church was reopened on Sunday 21 October 1860.

Inside, by the north wall of the chancel is the recumbent alabaster tomb of William and Ann Sneyd surrounded by their fifteen children.

The sandstone tower – 78 feet high with the spire adding a further 65 feet – stands unusually on the north side of the church. It is home to a 14cwt ring of eight bells, the oldest of which were cast by Rudhalls in 1714 and until 1752 hung in Trentham church. In 1767 six bells were sold to Wolstanton at 9*d* (4.5p) per Ib and for the same amount one large bell was purchased by Trentham from Wolstanton. They were augmented to eight in 1884 with the addition of new treble and tenor bells. However, there is an anomaly with the fifth bell – the old Trentham fourth – in that *c*. 1884 it was transferred to St Andrew's Church at Porthill (not completed until 1886) and a new bell cast for Wolstanton. Records remain unclear on the origin of the fifth bell. The clock mechanism sits above the ringing chamber and remains one of the few hand-wound public clocks.

Inside St Margaret's
Church looking
towards the chancel
and altar. (Author's
collection)

45. WOMBOURNE, ST BENEDICT BISCOP ANGLICAN CHURCH

Wombourne is the only English church with a dedication to St Benedict Biscop
(*c.* 628–12 January 690), the Benedictine founder of Monkwearmouth and
Jarrow abbeys. He is said to have introduced stained-glass windows into England
and is their maker's patron saint. He became the first Englishman to consecrate art
to Christian observance.

It is thought that the first church on the site was built as a chantry to pray for
the deceased following the AD 910 Battle of Tettenhall when Saxon Edward the
Elder defeated the Northumbrian Danes.

While the red-sandstone tower is fourteenth century – with a 9cwt ring of eight
bells – and the grey steeple above fifteenth century, the adjoining medieval church
had become too small by the nineteenth century and in 1840 a new building with
galleries was constructed in the style of Strawberry Hill Gothic. However, this was
short-lived as George Edmund Street razed the church again and rebuilt it to include
features of different architectural styles, giving the appearance that it had developed
over time. Ostensibly the chancel windows appear to be thirteenth century, the
south aisle windows are of Early English lancet style and those in the north aisle
perpendicular, as in fourteenth- to seventeenth-century England. The work was
undertaken by Messrs Higham of Wolverhampton at a cost of £3,500. Today, all that
survives of the medieval church is the lower part of the north nave wall. St Benedict
Biscop's was reconsecrated on Tuesday 20 August 1867 by the Bishop of Rochester.

Inside, the sandstone Gothic-style font is considered to be the only survivor from
the 1840s church. Also, an alabaster carved tablet depicting the Good Samaritan
was bought from Italy by Sir Samuel Hellier in 1720 and later donated by Thomas
Shaw Hellier. On the north wall is a Victorian marble memorial sculptured by the
renowned Francis Chantry to Richard Bayley Marsh of Lloyd House (d. 1820).

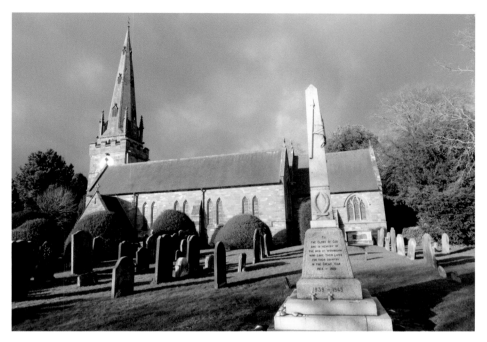

Wombourne Parish Church, the only one in England to be dedicated to St Benedict Biscop. (Author's collection)

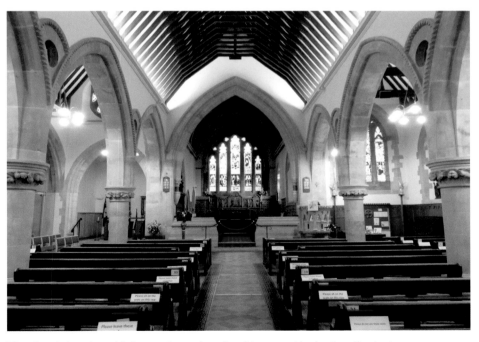

The church interior with its varying styles of architecture. (Author's collection)

BIBLIOGRAPHY

Bird, Vivian, *Staffordshire*
Dove, R. H., *Church Bells of Britain*
Fisher, Michael, *Pugin Land*
Greenslade, Michael, *Catholic Staffordshire*
Lewis, Roy, *Stafford Past*
Mee, Arthur, *Staffordshire*
Scarisbrick, J. J. (et al.), *History of the Diocese of Birmingham*
Sister Valery OP, *Mother Margaret Hallahan*
Tomkinson, John L., *A History of Hulton Abbey* (Staffordshire Archaeological Studies)
Tomkinson, John L., *Monastic Staffordshire*,
Ward, John, *The Borough of Stoke-Upon-Trent*

The National Newspaper Archives